Calligraphic Flourishing

CALLIGRAPHIC Flourishing

A New Approach
to an
Ancient Art

Bill Hildebrandt

D·R·G

DAVID R. GODINE, PUBLISHER
BOSTON

First published in 1995 by
DAVID R. GODINE, PUBLISHER, INC.
Post Office Box 450
Jaffrey, New Hampshire 03452
www.godine.com

LIBRARY OF CONGRESS CATALOGING-IN-PUBLICATION DATA

Hildebrandt, Bill, 1927-
Calligraphic flourishes: a textbook on the art, theory,
and practice of flourishing / by Bill Hildebrandt
p. cm.
Includes index.
ISBN 1-56792-028-4
1. Calligraphy. I. Title
Z43.H65 1995
745.6'1977—dc20 94-24647 CIP

Second Printing, 2002
Printed in the United States of America

To Goodwife Phyllis, who has kept me flourishing through the years

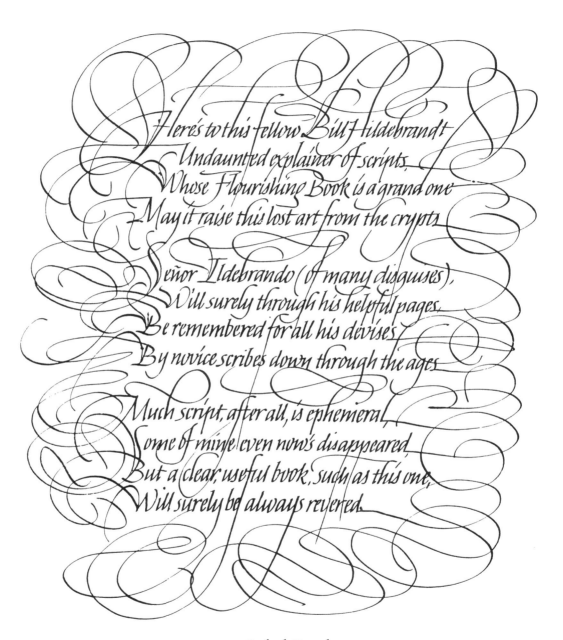

Here's to this fellow Bill Hildebrandt
Undaunted explainer of scripts,
Whose Flourishing Book is a grand one
May it raise this lost art from the crypts

Señor Ildebrando (of many disguises),
Will surely through his helpful pages,
Be remembered for all his devises
By novice scribes down through the ages

Much script, after all, is ephemeral,
Some of mine even now's disappeared,
But a clear, useful book, such as this one,
Will surely be always revered.

—Raphael Boguslav

Preface

"The time has come, the calligrapher said, to talk of many things,
Of cadels and of flourishes, and why the pen nib sings,
And how the moving fingers write as though the hand had wings."
...with apologies to Lewis Carroll

Many students, after having had a few lessons in calligraphy, begin to see the wonderfully wide spectrum that calligraphic art embraces and then decide they want to learn and perfect all aspects at once: classical scripts, modern scripts, decoration, gilding, pen making, layout and design, and of course, flourishing! This is a noble aspiration, but a rather futile one, considering that Western calligraphic art alone comprises some 2000 years of development of scripts, materials, techniques and philosophy. The student's problem is more difficult today than it was in medieval times. Today's student sees the entire history of the art with the best examples reproduced in endless books and at conferences and meetings. The medieval scribe, on the other hand, was generally taught, and concentrated on, only one aspect of the process: layout, writing text, decoration, gilding, binding, etc. So, it is usually better to try to master one or two areas of the art at a time, at least up to a level of some proficiency and not attempt to spread one's efforts too thin.

Flourishes are usually used to ornament or embellish text, and so you should be able to write out some text to embellish. But it certainly isn't necessary to wait until you have mastered several scripts before learning the very enjoyable art of flourishing. In fact, the techniques needed for graceful flourishing are also those required for good calligraphy, and studying both will result in benefits for both. Hardly any "how to" books on calligraphy (and very few of the many calligraphy teachers of today) stress or even mention the dynamics and kinesthetics of moving the pen, which are

necessary for good letterforms and good flourishes. This book will attempt to fill this gap, as well as provide a new and learnable approach to flourishing.

This book grew out of two studies: one was a week of delving into classic Fraktur and the Baroque flourish in 1982 with Raphael Boguslav (who is one of the few teachers I've ever heard mention the dynamics of pen motion). The other began on Thanksgiving Day in 1978 when I noticed a similarity between some decorative work by Johann Schwander (Calligraphy, Dover Reprint, 1958) and a simple doodle I had been playing with off and on since the early 1960s, which led me into the wonderful world of cadels.

The Flourishing Alphabet was developed in 1983 as a direct result of Raphael's workshop and has served as a basis for my flourishing workshops since that time. I am indebted to Raphael for his one week workshop which opened my eyes to the structure of flourishes, and to the late Stephen Harvard for his permission to reproduce cadel examples from his book, "Ornamental Initials."

I would like to thank Raphael Boguslav and John Neal for reading the manuscript and offering their comments and encouragement. Thanks also to Alexander Nesbitt for permission to use two figures from his book, "The History and Technique of Lettering", and to Jean Larcher, Michael Sull, Chris Stinehour, Fran Strom Sloan, and Raphael Boguslav for allowing me to reproduce examples of their work. A word of appreciation must go to Nancy Green of Design Books and to David Godine for their suggestions regarding the design of this book, to Ken Wong for his considerate and careful proofreading, and also to Judith Abraham, P.T., for her help in identifying the muscles used in moving the pen. Finally, a thank you to the many teachers and others who, through personal contact or through their work or writing, have inspired me in the wonderful study of calligraphy.

<div align="right">

Bill Hildebrandt
West Simsbury, Connecticut

</div>

Contents

Introduction

Read this first! This book will introduce beginners to the art of flourishing and will give professionals a new and useful way of looking at and analyzing flourishes. The methods developed can be applied to the broad edged pen, the pointed pen and to brush calligraphy. It is important that the beginner (and probably many advanced practitioners) read through, understand, and attain proficiency in the techniques described in Chapter 2, "The Dynamics of Flourishing." Not only is this a "must" for good flourishing, but it will greatly improve the calligraphy of many scribes who have never learned to write properly.

This book may be used in several different ways. You may read through it page by page and do the examples as they are suggested in the text. Or you can just look at the examples and try your hand at executing some of the flourishes you like. The first way is undoubtedly the way to derive the most benefit from the book. The accomplished calligrapher can use the book as a reference; the index will allow the location of specific examples or methods when necessary.

A good deal of the material in this book is novel and different, especially the emphasis on pen dynamics, the methods of analysis and evaluation of flourishes, and the material on cadels. Careful study will give the student a new and refreshing approach to an old subject.

The sections on tools, materials and history need not be read by those familiar with these subjects. Indeed, these are as rudimentary as possible so as to give maximum space to the main subject. In any case, no matter how you use this book, do not skip the chapter on the dynamics of flourishing.

<div align="right">Guillermo Ildebrando</div>

1
Beginnings

Contrary to current cosmological conjecture, the universe did not originate with a big bang, but with a flourish. —Guillermo Ildebrando

WHAT IS A FLOURISH?

The *Reader's Digest Great Encyclopedic Dictionary* defines the word *flourish* in part as follows: "v.i. to move with sweeping motions; to be displayed or waved about. To write with sweeping or ornamental strokes; to embellish, as with ornamental lines, figures, etc. — n. a curved or decorated stroke in penmanship. From the Latin *florere*, to bloom." Considering the resemblance of a graceful flourish to a vine or flower stem, the Latin root (pun intended) of the word becomes obvious. Another word for a flourish which is used in the typographic field is "swash," and finally the word "paraph" is applied to a flourish used to protect a signature from forgery. Later on we shall show how flourishing relates to vinework illumination, Celtic knotwork, cadels and knots in general.

DIFFERENT KINDS OF FLOURISHES

Flourishes may be classified in a number of different ways. They may be used to embellish text or they may be used alone as ornaments. As text embellishments, flourishes may take the form of extended strokes or serifs, added strokes, visible stroke sequences, or interrupted strokes. Some of these forms may be thought of more as decoration or ornamentation than flourishing, but the concepts overlap in many areas. We may also classify flourishes as to style, viz. curvilinear or angular, the latter being known as cadels. Using the letter R, these categories are illustrated in Fig. 1. Flourishes may also be classified by the technique used in rendering them, e.g. drawn and filled, freely written, etc. This book will cover curvilinear flourishes

1

as stand alone ornaments and as text embellishments first. Cadels and other approaches will be discussed in Chapters 6 and 7.

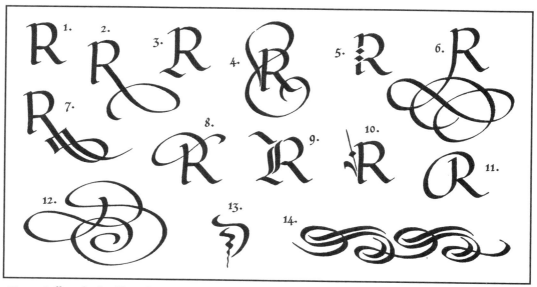

Fig. 1. Different kinds of flourishes: 1. Plain letter; 2. Extended stroke; 3. Extended serif; 4. Appended flourish; 5. Interrupted stroke; 6. Extended stroke; 7. Extended stroke with cadel flourish; 8. Extended stroke; 9. Doubled stroke & flourished serifs; 10. Added strokes; 11. Visible stroke sequence; 12. Stand alone flourish; 13. Simple tailpiece; 14. Border elements.

TOOLS AND MATERIALS

Since flourishes are generally added to written letters, the tools and materials used are the same as those for regular calligraphy. That's the end of the section on tools! All right, a few words on the subject, but just a few; any of the many fine books on calligraphy will provide a good overview of this area. However, flourishing may put more demands on the tools than ordinary lettering does. Although many formal scripts (and flourishes, too) are executed with pull strokes only, the so-called offhand or free flourishes are done with no pen lifts, and require the pen to be pushed as well as pulled. Thus, the tool must be capable of being pushed without snagging or catching in the paper. This is no problem for either the pointed brush or the flat brush, except

that the calligrapher must see to it that the brush is not pushed against the hair or bristles unless a spattery or rough effect is desired.

For metal broad edged pens, pushing can be scratchy unless the nib edge is smooth and free of burrs and sharp edges and corners. This usually does not preclude sharp thin strokes but the nibs must be prepared carefully. Quill, reed and bamboo pens are generally smoother in push strokes because of their softer material. For the beginning flourisher, a good quality fibre tipped edged pen is advisable to start with. These will both push smoothly and allow the student to learn the dynamics without being hindered by scratchy metal nibs. Another possible choice for flourishing is the fountain pen, although as manufactured these may not give the thinnest thin strokes. They can be reshaped and a good compromise can be had between smooth pushing and thin hairlines if the nibs are carefully shaped.

Pointed pens are another subject altogether. The pointed nib end has two rather sharp prongs which contact the writing surface, and the slightest excess force during a push stroke will cause snagging. Lightness of touch, which is required for most flourishing, is essential here, and will be dealt with subsequently. However, the choice of nib is important, since the pointed nib, if excessively scratchy, is difficult to repair, and there are no fibre equivalents. So it is important that the student obtain well manufactured nibs, and unfortunately these are hard to find these days. The best ones come from older stock and are worth searching for. (See Suppliers, page 110.)

Inks must be free flowing; any water based ink or paint will suffice, but pigmented inks or paints may have to be thinned to flow freely. Papers can be rough or smooth depending on the effect desired. A smooth paper is advisable for beginners, but once the proper touch is acquired rougher surfaces can be tried.

One must not overlook the humble pencil as a flourishing tool: a pencil can be used as a layout or improvising tool to work out new flourishes, and the "double pencils" tool is excellent as a layout tool for larger broad pen flourishes. The equivalent for

large pointed pen flourishes is the 'Whopperplate® pen (Fig. 2). The computer, as a graphic design tool, can be used to design and execute flourishes through any of the

drawing programs available with either a mouse or a drawing tablet. It can also serve as an editing tool to clean up hand written flourishes which have been scanned. In any case, the material in this book is relatively independent of the tool used and can be adapted to many different materials, tools and approaches.

Figure 2. The use of double pencils

HISTORY

We humans have an innate desire to decorate. After we have invented or made something that satisfies us functionally, we then want to make it pleasing in appearance. And so it seems to have been in the development of writing. This book will be limited to 'Western calligraphy, and we can look for the roots of flourishing in the early Roman cursive. This was written with a stylus on a wax tablet or with a calamus (a reed brush) on papyrus, parchment or rigid surfaces like pottery or walls. Basically, flourishes are extensions of letter strokes beyond what is necessary for readability, and this can be clearly seen in the Roman cursive (Fig. 3). This was probably not done as an attempt at ornamentation but most likely because it felt good. It is easier and more satisfying to allow the pen or stylus to "follow through" on a stroke than it is to stop it dead in its tracks.

Figure 3. Roman Cursive, 4th c. (from "The History and Technique of Lettering" by Alexander Nesbitt, Dover Publ.)

Some examples of Roman Rustic capitals that have come down to us do show flourishes which may have been more conscious attempts at decoration than just follow through (Fig. 4). Most formal book manuscripts, however, do not exhibit

Rustica ~ 5th century

FELICESOPERVM·QVINIAM[V

Figure 4. Roman Rustic, 5th c. (from *"The History and Technique of Lettering"* by Alexander Nesbitt, Dover Publ.)

what we would call flourished decoration until around the 13th century, when some of the filigree decorated capitals began to show what might be called freely flourished strokes. On the other hand, the documentary scripts continued to develop the stroke extensions of the Roman cursive. Royal charters as early as the 7th c. used flourish strokes for ornamentation, protection against forgery, and to make it difficult for the uninitiated to read. This trend in the documentary hands continued right through to the Renaissance, when such formal hands as cancellaresca corsiva were amply decorated with flourishes. During this period the use of copperplate engravings in printing and experiments with the pointed pen led to scripts of the Copperplate genre and to the Baroque flourishes used with the German Fraktur scripts. At this time also we see the cadel flourish appearing in manuscripts and designed into initial letters in early printed books.

With the advent of printing, and the decline of hand written books, the traditional book scripts fell into disuse, but commercial and documentary scripts received new vigor from the expanding world trade and economy. The era of the writing master and teacher had begun and free flowing flourishes were used as pure ornamentation, as protection against forgery and as dazzling pieces of showmanship, where birds, animals and people were "drawn" with flourish strokes. Fig. 5 gives just a taste of the

tremendous variety of flourish styles that can be found in surviving manuscripts from different periods. For a serious study of historic examples, the student is referred to the Bibliography for sources of reproductions.

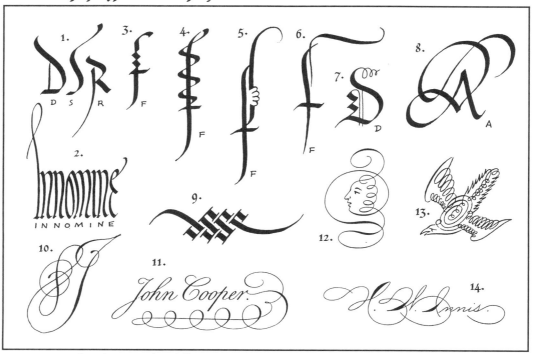

Figure 5. Some flourish varieties from different periods: 1. 5th century; 2. 8th century; 3 & 4. 12th century; 5 & 6. 13th century; 7. 15th century; 8 & 9. 16th century; 10 & 11. 17th century; 12. 18th century; 13. 19th century; 14. early 20th century. (Examples 1 through 10 rendered by the author; 11 & 12 are from Bickham's "Universal Penman," Dover Publ.; 13 is from "Gaskell's Guide to Writing, Pen Flourishing, etc." and 14 is from "C. C. Canan Collection," Zaner-Bloser Co.)

WHY FLOURISH?

Flourishing is fun; it gives the calligrapher the opportunity to express emotions, to make a written record of the physical joy of writing and the dance of the pen. It provides a wonderful source of decorative material for calligraphic works, and a way to add infinite variety to your letters and words. Flourishes can be used with any alphabet, and standing alone they can create headpieces and tailpieces, cartouches,

borders, frames, logos and background patterns. Flourishes can also be used as part of a person's signature as a guard against forgery; used in this way they are known as "paraphs." And as for calligraphic therapy, there is nothing better than learning the proper techniques of flourishing to improve your pen or brush handling. And besides, it's fun!

A WARNING

The fine British calligrapher and teacher, Peter Thornton, has said, "If you can't flourish, don't try to prove it." Poor letterforms and poor layouts are bad enough without adding an ungraceful attempt at flourishing to a piece. And many an excellent calligraphic work has been ruined by a poor flourish. The reader's eye will be drawn to it and the reader's subconscious mind will keep asking, "How could the calligrapher have done that to such a nice piece of work?" So, until you can flourish gracefully, practice in the privacy of your studio. Devote some time to the exercises and ideas in this book; try to understand the philosophy behind the methods described, and practice even more. And then, when you can flourish, do go out into the world and prove it!

2

The Dynamics of Flourishing

"It don't mean a thing if you ain't got that swing."
—Irving Mills

The "Dance of the Pen" is no idle phrase as it relates to calligraphy. The dynamics of body motion in dance are closely akin to the dynamics of graceful pen motion in calligraphy. The Victorian writing masters were insistent on proper dynamics in writing technique, and it is unfortunate that few contemporary teachers call attention to these methods, or even know the reasons for them.

The requirements of flourishing, as well as writing calligraphic scripts, are such that without proper dynamic technique the student will rarely produce smooth and graceful results. In this section, we will treat the pointed pen as used in Copperplate and Spencerian scripts, because this requires a bit more finesse than the broad pen. However, the material pertains directly to broad pen work and brush work also.

MOVING THE PEN

There are basically three methods of moving the pen to form letters: finger writing, forearm (or hand) writing, and a combination of the two. Beginners usually form their letters by resting the hand and forearm on the writing surface and flexing (bending and straightening) the first two fingers and thumb, which also hold the pen. (See Figs. 6 & 7.) Unless the student is instructed differently, this will seem to be the easiest way to achieve the control needed to duplicate the model letters. And unless shown the problems that this "finger writing" can cause, most students will continue to learn scripts in this way and will rarely achieve the graceful and free flowing results they seek.

There are several reasons for this. First, the fingers are called on to perform three different muscular tasks: 1) to grip the pen; 2) to hold the pen against the paper, and for most pointed pen scripts, to vary the force of the nib against the paper to form the

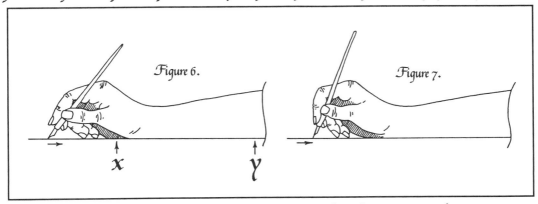

Figures 6 & 7 together illustrate the action in finger writing. Figure 6 shows the resting points in forearm writing.

thicks and thins; and 3) to trace the contours of the letterform itself. Although the fingers can do all three jobs, the results are never quite as smooth as desired, and can be very halting and jerky. Second, using the fingers limits the length of stroke which can be made smoothly. This effect can show up as soon as strokes greater than three or four mm are attempted. Third, finger writing tends to cause the angle of the pen staff to vary with respect to the plane of the paper (see Fig. 8) and can cause the force of

the nib against the paper to vary, making it difficult to control thicks and thins. This can also cause the nib to dig in and catch on the up strokes. Fourth, the moving system in finger writing (i.e. the parts that move when writing, that is, the pen and parts of the two fingers and thumb) has very little mass (inertia) and can easily be bumped

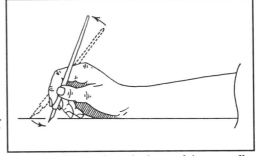

Figure 8. Showing the angle change of the pen staff in finger writing.

away from a smooth line by nib and paper surface roughness. Forearm writing eliminates these problems as will be shown in the next section.

FOREARM WRITING

Forearmed is forewarned! The basic idea of forearm writing is to separate the jobs of holding the pen, pressing it against the paper, and tracing the letter shape, so that each of these functions can be performed with a different set of muscles. First, the fingers are used to grip the pen and that is all they do. They do not flex while tracing the letter contour (except in the so-called combined technique, where a very small amount of finger and wrist flexing are allowed: just enough to cause a few mm of nib motion. Once the student has the feel of forearm motion with the wrist locked, a small amount of finger and wrist flexing may be added. Wrist flexing should be limited to strokes of about 15 mm and finger motion to strokes of one to two mm.) Next, the forearm muscles are used to press the pen against the paper, and to vary the force to form thicks and thins when using the pointed pen. (As an experiment, place your forearm and hand on the writing surface in your writing position, hold the pen with your fingers, and without changing the force of your grip on the pen, see how you can lift the pen off the paper and then press it down without flexing your fingers.)

Finally, the pen is traced around the contour of the letterform by moving the forearm and hand without flexing the fingers. This motion is controlled by the muscles in the back, known as the shoulder girdle. It is this motion that students seem to fear most; they think they will not have the control necessary to make small letters. It may take the average finger writer a little practice to acquire the necessary skill and confidence, but the smallest letters can be made with the highest precision in this way.

The second part of the technique involves the resting or reference points. That is, it concerns those parts of the body that rest on the paper to give control and stability to the pen-body combination. There are three schools of thought on this. The first allows

the forearm to touch the paper at y (see *Fig.* 9) and the tips of the ring finger and pinky to touch at z. The hand does not touch the paper at x but the finger tips slide on the paper at z. For strokes up to about 25 mm, the flesh of the forearm resting on the paper flexes and for larger strokes, it slides on the paper.

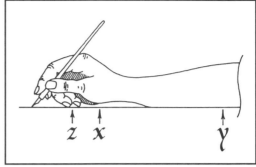

Figure 9. Alternate rest points in forearm writing.

The second approach is to have two possible rests for the hand and the arm. For small strokes up to about three or four mm, the hand rests on the paper at x, (see *Fig.* 6) and flexes as the shoulder girdle guides the pen around the letter contours. For larger strokes, up to about 25 mm, the hand slides at x and the forearm flesh resting on the paper at y flexes. For larger strokes, both x and y slide on the paper and what is known as whole arm motion occurs. Finally the true offhand flourish is done with only the pen nib itself touching the paper. It is interesting to note that with a little practice one can be writing small letters with flex contact at both x and y, and without stopping or lifting the pen, one can go into a flourish with whole arm motion, and then come back to the small stroke mode quite smoothly. With the mass (inertia) of the arm behind the pen, the strokes will be smooth and graceful.

ADVANTAGES

With these techniques, the pen shaft never changes its angle with respect to the plane of the paper, and by controlling the pressure of the nib against the paper with an independent set of muscles, the nib can skate on the paper with the lightest force to give exquisite thin strokes. Since the tracing of the letter shapes is controlled independently by the shoulder girdle, the placement and control of the thick strokes (swells or shades) can be controlled without affecting the letter shape. Finally, with the mass

of the hand and arm combined behind the pen, the strokes that result are smooth and graceful with no hitches or jerkiness. Incidentally, to insure achieving a feather touch on the paper for the thin strokes using the pointed pen, five or six sheets of newsprint should be used under the writing sheet as a cushion. The newsprint does not compact itself solidly and actually provides an "air cushion" on which the nib can ride. This is helpful for broad pen work also.

Forearm writing is equally advantageous for the broad pen scripts, even though the force variation needed for shades with the pointed pen is not necessary. Using the arm will result in smoother and more graceful broad pen letters and flourishes, and some techniques such as pressured capitals will benefit from the independent muscle group control.

ADDITIONAL GRIPS

The subject of ornamental flourishing as practiced during the Victorian era, with its wonderful birds and animals made up of flourish strokes, will not be attempted in this book. The pen grip and motion will be described however, and those desiring to move on to that art will find an excellent manual in "Ornamental Pictorial Calligraphy" by E. A. Lupfer, Dover Publications, 1982. The ornamental flourishing grip is shown in Fig. 10, and strokes are made entirely with forearm motion,

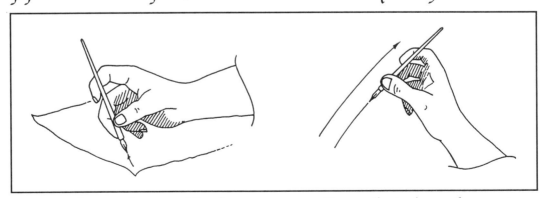

Figure 10. The pen grip for ornamental flourishing. Figure 11. Showing the proper forearm motion.

moving the pen (for right handers) away from the body at an angle of about sixty degrees as shown in Fig. 11. The pen is held between the thumb and second finger. The index finger just supports the pen staff as shown. This grip and motion allow very long controlled strokes to be made with smoothness.

For flat brush work, using regular square edged flat brushes (not signwriter's quills, which require a different technique altogether), the brush handle is held almost vertical to the plane of the paper to get the full benefit of the chisel edge in the thin strokes and to allow push as well as pull strokes without causing the brush hair to buckle (Fig. 12). Otherwise the flat brush can be used just like the broad edged pen. The pointed brush as a calligraphic tool can be held in much the same way as the broad pen but should not be pushed or else the hair will buckle. However the pointed brush can be held vertically like the flat brush and can be pushed and pulled with no problem. There are so many pointed brush lettering techniques that they can not be covered here. Several good books are available on this subject.

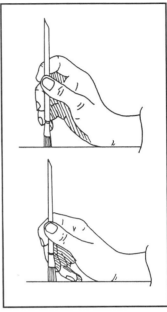

Figure 12. Flat brush grips.

EXERCISES

The exercises shown here are not new by any means; though they may seem like third grade work from a Victorian elementary school, they are extremely important in developing the proper dynamics for flourishing and calligraphy. Any writing tool may be used, even a pencil or ball point pen, but a 1 mm smooth writing fountain pen or fibre calligraphy pen is preferred. If you are a pointed pen person, use your favorite nib. All exercises may be done with either a broad pen or a pointed pen.

To get the feel of the forearm motion, the first strokes should be across the full width of the paper (Fig. 13) and then down the full height of the paper (Fig. 14). Each of these strokes should take about two to three seconds. Keep them parallel and under control. One sheet of each will show you what the arm can do. If there are any questions about moving the pen, reread and study the section on forearm writing.

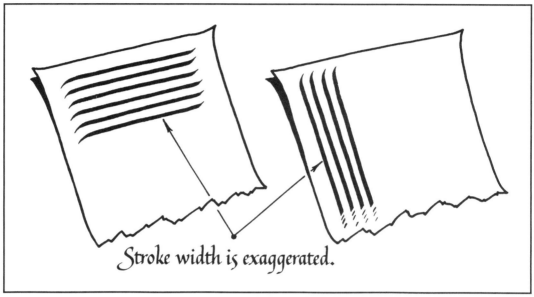

Figures 13 & 14. First exercises in forearm writing.

Next come the time honored ovals and push pull exercises (Fig 15). These are fine warm-up exercises to use before starting your calligraphy session even after you are an "expert." The student should do ovals and push pulls (and most other exercises)

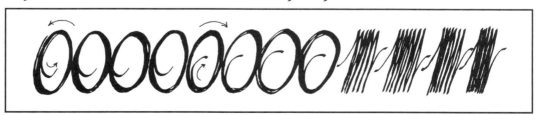

Figure 15. Ovals and push-pulls. These are excellent warm-up exercises for all calligraphy work.

rhythmically at about 100 strokes per minute (slightly less than two per second). Start slowly, however, to get the feel of control. Remember, no finger writing! The fingers only hold the pen; the shoulder muscles move the pen.

For those who have never used their arms in this way, a good way to start is to make the ovals and push pulls about two inches high. When that feels comfortable, go to one inch, and then even smaller. You will develop control so you can do these at one and two millimeter heights without feeling you have to flex your fingers.

Another excellent warm-up exercise is shown in Fig. 16. This stroke should be mastered in all eight orientations as shown. Begin with #1 which is the easiest for beginners. Orientations #5 through #8 are more difficult, but they are important since they involve pushing the pen at the start of the stroke. Repeat each one several times until they can be done gracefully with proper arm motion. The strokes should be done two to three inches high.

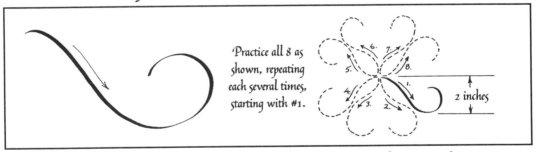

Figure 16. Another warm-up exercise showing eight angular orientations for practice strokes.

POINTED PEN FLOURISHING

These exercises are all illustrated with the broad edged pen but can be done as effectively with the pointed pen by those working with Copperplate or Spencerian scripts. Some notes and a series of exercises and examples for the pointed pen can be found in Chapter 9 starting on page 91. It is advisable to get a good feeling for broad pen flourishing before proceeding to the pointed pen.

3

An Alphabet of Flourishing

Learn the ABC of flourishing before you try to ascend to its summit.
—with apologies to Ivan Pavlov

WHY AN ALPHABET?

Many calligraphers feel that flourishing can't be taught because there are so many ways of flourishing with so many different degrees of complexity and variations of pattern. But all flourishes (as well as all letterforms) can be broken down into basic strokes. And to make the analysis and execution of both simple and complex flourishes easier, we'll give names to the different kinds of strokes. Learning any art or craft is a lot easier if we can talk and think about the various things we learn by name. As soon as we name a thing, it becomes less mysterious and more friendly.

STRAIGHTS AND CURVES

The simplest flourish stroke is the straight stroke (Fig. 17). These should be practiced in several ways. One is to place the nib on the paper, edge in, draw the stroke, stop, edge out and lift the pen. This gives a rather static but useful stroke. A more dynamic stroke is obtained by drawing the stroke, edging out and lifting the pen without stopping the pen motion, sort of like an airplane taking off. A third way is to be like an airplane landing, and have the nib hit the paper at the start of the stroke while the arm is moving; this gives a smoother beginning to the stroke. Finally, you can have the nib hit the paper while moving, and lift off at the end of the stroke while still moving.

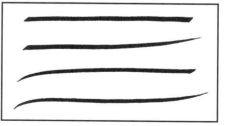

Figure 17. Straight strokes.

16

THE SIMPLE CURVE

Although the straight stroke is the simplest, it is sort of unnatural, most things in nature being curved to some extent. So the curves are next (Fig. 18). To help in understanding complex flourish designs later on, we will talk about two kinds of curved strokes: clockwise (cw) and counterclockwise (ccw). Practice these as well as the other strokes in different orientations and directions, cw, ccw, top to bottom, bottom to top, left to right, etc. Note that curves can take different forms and proportions. They can be gentle or sharp, or they can make almost a complete circle or oval.

Figure 18. Simple curves

THE S-CURVE

We can now form our first compound stroke: the s-curve, (Fig. 19) which can start with a cw curve and end with a ccw curve, with perhaps a straight portion in the middle. (Or it can start with a ccw curve and end with a cw curve.) The s-curve is a very natural stroke and should be practiced in all directions and sizes. Again notice the different varieties the s-curve can assume.

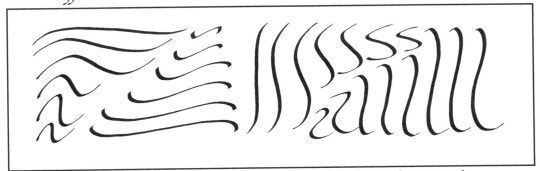

Figure 19. The S-Curve shown in different orientations and shapes. They can be sharp, gentle, symmetrical, or asymmetric.

SPIRALS

Spirals are essentially curves that keep going around (*Fig. 20*). The most useful and esthetically pleasing spiral is known as the *Spiral of Archimedes*. This spiral is one where the width of the white space between the turns is more or less constant. The reasons for the uniform white space will be discussed later. (*Trust me!*) Spirals can be circular or oval, cw or ccw, and can be decreasing or increasing in size. Generally spirals in flourishes have no more than two or three turns, otherwise they can become boring optically.

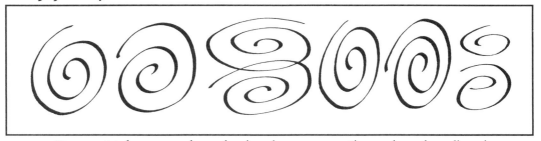

Figure 20. Spirals can start at the outside and spiral in or vice versa. They may be circular or elliptical.

LOOPS

Loops are curves which keep on curving, but unlike spirals, loops cross themselves after one complete turn as in *Fig. 21*. Although they are essentially the same, we will call loops on the inside of a flourish design "inside loops" and those outside,

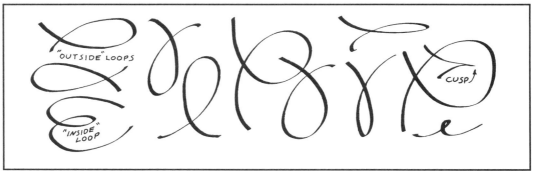

Figure 21. Loops, showing different shapes. Note that loops can be described as inside or outside loops, or left or right loops.

"outside loops." Again study the different shapes and proportions loops can take. Note especially that loops can be so sharp that practically no white space appears inside the loop. A loop so sharp as to have no white space inside is still a valid flourish component and is called a cusp. See Fig. 24, example 9.

SPIRAL EXITS

A complex flourish is made up of the basic elements joined together in some combination. If the path of the pen enters a decreasing spiral, the flourish doesn't have to end inside the spiral. The path can continue via a "spiral exit." This can occur in two ways. A nonreversing exit is made when the path inside the spiral crosses itself to form a loop, and then proceeds to cross the other turns of the spiral while continuing to rotate in the same "sense" (i.e. cw or ccw) as the spiral. See Fig. 22. A reversing exit occurs when the exit stroke forms an s-curve as it exits. Thus a reversing exit can be seen to be a combination of a spiral, a loop and an s-curve. It is convenient, however to treat it as a basic element in analyzing flourishes. The limiting case of a nonreversing spiral exit is just a simple loop. The limiting cases of the spiral exits are shown in Fig. 22.

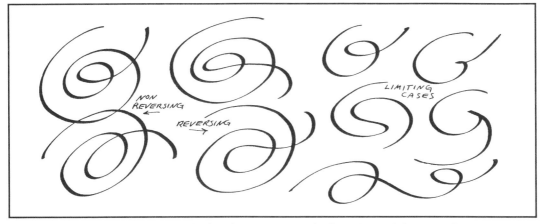

Figure 22. Spiral Exits. To exit a spiral, the flourish trace crosses itself to form a loop and then crosses the other turns in the spiral, either forming an s-curve (a reversing exit) or not (a nonreversing exit.) Four limiting cases are at the upper right.

SCALE

When we learn a calligraphic alphabet, we generally find that a nominal pen scale is recommended: e.g., an x-height of so many pen widths, etc. Flourishes have no x-height but do respond to pen width changes as shown in Fig. 23. For a given size loop, a very narrow pen will make the loop appear monotonic (i.e., very little thick or thin differentiation) whereas a very broad pen will leave no white inside the loop. The heaviness or lightness of a flourish is thus controlled by the pen width and is chosen, generally, to harmonize with the density of the text being embellished.

Figure 23. Scale. This shows how the appearance of a flourish changes with stroke width.

A review of the basic flourish elements is shown in Fig. 24 for easy reference. Each of these should be practiced in all the different variations, shapes, orientations, scales and senses with smooth arm motion. It is best to start large: loops and spirals at least one inch in diameter. Learn form slowly; speed follows after structure is absorbed mentally so that a shape can be executed without following a model sheet.

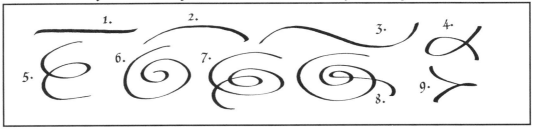

Figure 24. The basic flourish elements: 1. the straight stroke; 2. the simple curve; 3. the s-curve; 4. the outside loop; 5. the inside loop; 6. the spiral; 7. the nonreversing spiral exit; 8. the reversing spiral exit; 9. the cusp (limiting case of the loop).

REPEAT CHAINS

The next step is to practice the basic elements by combining them into simple chains, for example by repeating the loop element as in Fig. 25. Notice that this

exercise can be varied by changing the loop proportion so that the loops can be separate, touching or overlapped. Repeated chains such as these are excellent for achieving rhythm, good arm control and coordination. Other good chains comprise alternate up and down loops and alternate left and right loops (Fig. 26).

Figure 25. Repeat chains using loops showing the loops separated, touching and overlapping.

Figure 26. Repeat chains using alternate up and down loops, and alternate left and right loops.

Repeat chains of spirals require spiral exits and are good exercises to develop hand-eye-brain coordination. See if you can analyze the chains in Fig. 27 in words before

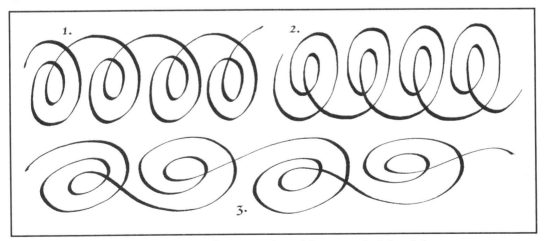

Figure 27. Repeat chains using spirals; write out the word description of each chain before practicing it.

you try them. Then check your verbal descriptions with those given at the right:

Another good chain exercise is to repeat loops but vary the orientation of the loops from one to the next (Fig. 28). Repeat chains have practical applications in the design of borders, text separators and line fillers.

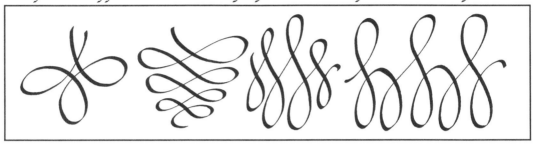

Figure 28. Repeat chains with loops of different orientations and varying size.

NONREPEATING CHAINS

Here is where we can begin to improvise, design, build and analyze complex flourish combinations. A number of examples will follow showing how the basic elements may be combined to form a great variety of flourishes. A good way to start is to take two elements and see what can be done by repeating and alternating them. The alternate up-and-down loop was one of these, but those elements were both loops. In Fig. 29, we start with a loop and a spiral, then see what happens with two loops and a spiral,

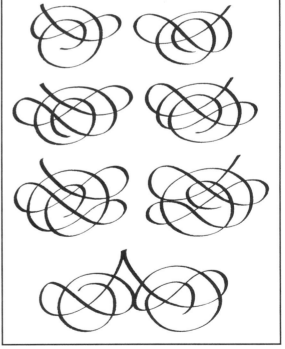

Figure 29. Nonrepeating chains with mirror images.

and develop a series of flourishes based on this. Then we try the mirror images of this series and finally combine one with its mirror image to achieve a symmetrical ornament. All of these forms should be practiced until they can be done gracefully and without referring to the models.

The student should at this point try making up some flourishes based on nonrepeat chains. One way to proceed is to pick out a combination of flourish elements and then try to actually construct the flourish with different element sizes, densities, etc. See if you can come up with well balanced graceful designs for each combination. A "mechanical" method of generating two, three (or more) element combinations is to use a table such as the one below. Here each of the non-trivial flourish elements is assigned a number. Now, for a three element combination, just choose three digits between 1 and 8 at random and try developing a flourish with those three elements connected in that order.

A Flourish Generator	
1. S-Curve	5. Spiral, outside entry, nonrev. exit
2. Inside Loop	6. Spiral, outside entry, rev. exit
3. Outside Loop	7. Spiral, inside nonrev. entry
4. Cusp	8. Spiral, inside rev. entry

For example, pick 3-4-5: An outside loop to a cusp to a spiral, outside entry, nonreversing exit. First just draw the three elements as a chain. Then try to arrange the elements into interesting compositions by varying the spacing, orientation and overlaps (Fig. 30).

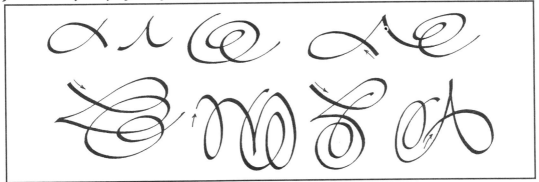

Figure 30. Variations on a "mechanically generated" flourish. Note that by chance this gave rise to a flourished letter A!

MULTIPLE STROKE FLOURISHES

Up to this point we have made our flourishes with one continuous stroke (except when we juxtaposed two mirror images). Now we consider using two or more strokes or separate flourishes in a single flourish "composition." Repeated curve strokes can form the basis of simple frames and repeated s-curves can form the basis of many interesting designs. Superposing one flourish on another with proper attention to spacing can give interesting results (Fig. 31).

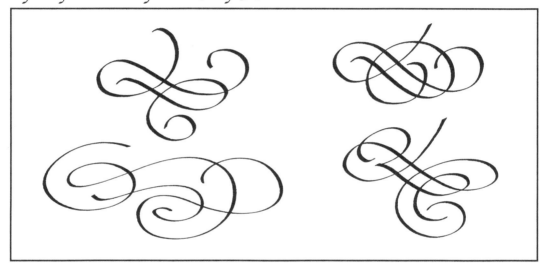

Figure 31. Some examples of flourishes made up of two separate flourishes superposed.

The student is encouraged to experiment with the ideas of Figs. 29, 30 and 31 to improvise some original combinations, using both single and multiple stroke approaches. The design or improvisation of flourishes to fit a given space or composition can proceed along strictly analytic lines (e.g., deciding on a sequence of basic forms and sizes and then executing them) or it can come from creative "doodling" where the subconscious "right brain" is free to play its own tune, so to speak. With any form of creativity, this requires fluency on the part of the creator. Fluency comes from having learned as many basic and complex forms as possible and having them at your

fingertips, literally. The more flourishing you have done, the more fluent and creative your efforts will be. A similar circumstance occurs in musical improvisation or composition. One does not pick up a musical instrument and improvise (compose) anything worthwhile without a great many exercises and a lot of practice on existing scales, arpeggios, melodies, etc. After the formal training the freedom can be invoked and you will have a much larger repertoire on which to improvise and create.

CLASSIFICATION OF TECHNIQUE

There are three basic ways of executing a flourish: 1) Drawn and rendered; 2) Formal, calligraphic; and 3) Free, calligraphic.

Drawn and rendered flourishes are just that. They are drawn with pencil and carefully rendered (filled in) with pen or brush and ink or gouache. Many graphic artists use this method when designing for reproduction. Details of this method will not be covered in this book, but a good exposition of the technique can be found in Tommy Thompson's "Script Lettering for Artists." However the methods in this book will give you the basis for the design of graceful flourishes that can then be drawn and rendered in this manner.

Formal calligraphic flourishes are done with pull strokes only, and as a result they generally require pen lifts. They are used when a particularly tight design is to be executed, where a design may have been originated as a free form continuous stroke flourish, but must be carefully fit into a prescribed space. The formal approach is also necessary sometimes when the flourish is very large, or the tool does not permit being pushed freely. One needs considerable practice and skill with the formal approach in order to achieve the grace and spontaneity of a free continuous stroke.

Finally, the free calligraphic flourish, which is done in one continuous stroke with no pen lifts, is the one covered in detail in this book. It forms the design basis for the other two approaches.

SPEED OF EXECUTION

Good flourishes, regardless of whether they are drawn and rendered, done with all pull strokes, or executed in one continuous stroke, should have the appearance of grace and spontaneity. As a result they may give the impression of speed, as though they were done very rapidly, but this is not necessarily true. Just as it is possible, and often necessary, to change from a hand rest mode to a whole arm mode and back again during the same continuous stroke, so speed in flourishing can vary from one part of the flourish to another. The speed of the pen at any point depends on the control needed for accurate stroke placement. Many flourishes that look like they were done at very high speed were in fact executed quite slowly. If the arm is properly used, even slowly executed flourishes will give the impression of speed and "dash." (Note: the word "dash" was used extensively by the pointed pen masters of ornamental penmanship of the late 19th and early 20th centuries to mean spontaneity, liveliness, snap, etc.) When learning the art of flourishing, the student should use proper pen dynamics and flourish slowly; control of the pen is more important than speed. There are times when rapid strokes are desirable, and the ability to execute them will naturally follow when control of the pen is mastered.

SIZE

Examples in this book should be practiced at least twice the size shown. Any smaller than this will not train the hand-arm-eye system properly. Don't overlook working even larger, say with a one inch felt or poster nib or brush (or Whopper-plate® for pointed pen work) and doing flourishes 18 to 24 inches or more high. Use the classified section of your newspaper for practice; it has an even gray tone and the columns make a fine line guide. Working this large involves the arm and body in a way that is both exhilarating and beneficial for your calligraphic technique.

4

What Makes A Good Flourish?

I can never feel certain of any flourish but from a clear perception of its beauty.
—with apologies to John Keats
Beauty in flourishes exists in the mind which contemplates them.
—with apologies to David Hume

It would have been nice had this chapter come at the beginning of the book, but it is best studied after you have an idea of what a flourish is and know how to do some. The following topics should be treated as the basis of a series of lessons and the student should practice the examples shown and try to make up others to illustrate the ideas discussed. A good flourish emphasizes and embellishes the text without overpowering it or diverting attention from it. (A good rule to follow is "less is more"; don't use a complex flourish when a simple one will do.)

WHITE SPACE CONTROL

A flourish where the white spaces are of the same order of size can appear to the eye as a homogeneous whole, with no part of it attracting the eye more than any other (Fig. 32). Any extremely tight areas with small white spaces tend to attract the eye and can distract the viewer. A great deal of what causes a person to like or not like a piece of calligraphy occurs in the subconscious mind. The untrained observer may not know exactly why they do or don't like a piece, but they often have very definite "feelings" one way or the other. Our visual systems and our subconscious minds pick up a lot of

Figure 32. Top: poor white space control results in a hot spot. Bottom: Same flourish opened up to even out white space.

information we may not be aware of consciously, and unless we are "in tune" with
the subconscious, all we are aware of are vague feelings of likes and dislikes. Simple
flourishes involving only one or two elements usually present no white space prob-
lems, but complex flourishes, which can appear as complete designs in themselves,
can usually benefit from a white space critique. Uniform white space distribution in
a complex flourish has the effect of unifying its structure and appearance.

HOT SPOT CONTROL

This is more or less a corollary of white space control. When there are too many
lines crossing in a small area, or the flourish is denser in one area, a hot spot occurs
which distracts the viewer from the rest of the flourish or
text. Generally more than two lines crossing at a point
(or in a small area), or thicks crossing thicks, will cause
a hot spot, as will a concentration of small white spaces.
An example of this is shown in Fig. 33. Since there are
exceptions to all rules, it must be noted here that there
may be times when a hot spot is desired to act as an
attention getter, and many graceful flourishes have been
made with triple crossings and thicks crossing thicks.
But these are exceptional and in general should be
avoided unless you have a good reason for them.

Figure 33. Top: Triple crossing re-
sults in a hot spot. Bottom: Same
flourish with hot spot avoided.

CONTROL OF SCALE

Flourishes, either as separate decorative elements or as text embellishments, should
harmonize with the other elements on the page. This is best accomplished by using the
same nib size for the flourishes as for the text, although sometimes flourishes are fin-
ished off, or hairlines are added, with a finer nib. In Fig. 34, the top flourish is too

thin for the associated lettering, whereas the second one harmonizes nicely. But in the third example, a very thin flourish on a heavy letter works because of the contrast and the placement of the flourish. In any case, a flourish generally should not overpower the text unless there are definite reasons.

CONTROL OF AMBIGUITY

The overall effect of a piece of calligraphy on the viewer is best when the piece appears as a unified whole, with a meaningful structure or composition. The same may be said for a flourish. Whether a flourish is seen as an emphasis of the text, a decoration, or an expression of the mood of the calligrapher, it should not overpower the text, or unduly call attention to itself. A complex flourish will work best if it forms an integral part of the composition and appears in itself as a complete design where no part attracts the eye more than any other part. Avoiding "hot spots" helps here, but there must also be no question (to the perceptive mechanism of the subconscious mind) as to the path or structure of the flourish. Visual ambiguities tend to subconsciously disturb the viewer.

Low angle crossings can give rise to this kind of problem. In Fig. 35 a we are not sure whether the two strokes are actually crossing, or are merely tangent. The low

Figure 34. Control of scale. See text above.

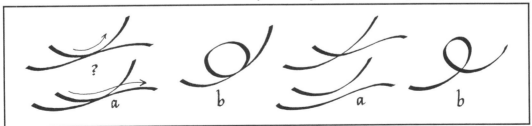

Figure 35 a. Do the lines cross or are they merely tangent? Fig. 35 b. Is this a loop or just a circle stuck on a curved stroke? These ambiguities can mar a flourish.

Figure 36 a. Either have the lines cross at a high angle or separate them to avoid ambiguity. Fig. 36 b. The larger crossing angle avoids the problem of Fig. 35 b.

angle of crossing in Fig. 35 b can give the loop the appearance of an oval that was stuck on to the curve stroke as an afterthought. In both cases the subconscious mind picks out these ambiguities, and the eye tends to be attracted to them as "hot spots." Making the angle between crossing strokes larger (Fig. 36) avoids these difficulties. In fact, when designing a flourish, an interesting and often productive exercise is to look ahead and try to cross existing lines in the flourish at nearly right angles. The example in Fig. 37 shows how this works.

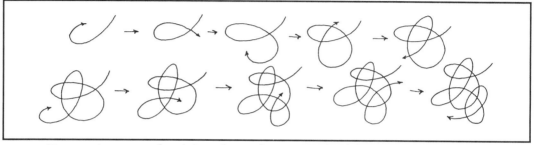

Figure 37. An exercise in flourish design: keeping the curves smooth and the crossings at nearly right angles.

STRIVE FOR SMOOTHNESS

Strive for smooth, graceful, dynamic curves and avoid jerkiness, awkwardness and ungraceful, abrupt direction changes (Fig. 38). The use of the arm in flourishing will usually guarantee graceful curves. Even if the pen skips and fails to leave an ink trace in part of the flourish, the arm's follow-through will finish the stroke gracefully. These gaps are variously known as phantom strokes, flying white space, or implied continuity. The last term actually describes what happens to the human perceptive

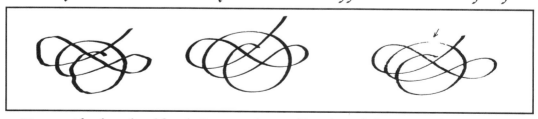

Figure 38. Left: jerky, awkward flourish. Center: smooth & graceful. Right: implied continuity or flying white space.

mechanism when it encounters a gap in a stroke. If the follow-through is graceful, the "eye" actually "fills in" or infers the continuity of the stroke. Gaps such as these are usually not retouched since they add life to the flourish.

Although abrupt changes in direction are usually to be avoided, there are cases where cusps can add visual interest to a flourish, as in Fig. 39, and abrupt angular changes actually form the basis for cadels, which will be treated in detail in Chapter 7.

Figure 39. Left: abrupt changes in direction can add interest. Right: a cadel flourish (see Chapter 7).

MAINTAIN VISUAL INTEREST

Try to vary the elements and combinations in complex flourishes. Maintain an even color (i.e. density, or darkness) while striving for complexity without ambiguity. Conversely, avoid the visual boredom of excessive repetition of elements unless a border or repeat design is desired. For example, more than two or three turns in a spiral will usually result in visual boredom, as will repeating the same type of element in the same size. Avoid aimless, ungraceful, wandering lines with no apparent purpose and which do not form a coherent design. See Figs. 40 and 41. Use transparent overlays to check on placement and appropriateness before doing finished work.

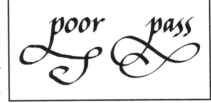

Figure 41. Left: aimless, wandering stroke. Right: same design with grace & coherence.

Figure 40. Top: excessive repetition; too many turns in spirals usually result in boredom. Bottom: less is more.

HARMONIZE

Flourishes should harmonize with the style and color (density) of the text being embellished. For example, the Italic minuscule is based on the oval, and this suggests that the flourish loops should be more ovate than circular. Humanist scripts, (Romans) based on a circular "o" could have flourishes with rounder loops, and Gothics would be at home with pointed or angular styles (Fig. 42). And, as mentioned before, using the same nib size as used for the text will help any decoration harmonize with the page. Sometimes it is fun to break the rules and see what happens when a flourish deliberately clashes with the style of the text (Fig. 43).

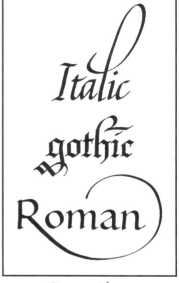

Figure 42. Harmony

STUDY GOOD MODELS

After learning to recognize the basic flourish elements, how they combine, and what makes a good flourish, the next step is to practice the principles and study good examples. There are a number of good books available with examples from different style periods, many of which can be had at reasonable prices as reprints from publishers such as Dover Publications (see the Bibliography).

At this point the student should review the points made in this chapter, and devise examples to illustrate the principles involved: white space control, hot spot control, control of scale, control of ambiguity, strive for smoothness, maintain visual interest, harmonize.

Figure 43. Breaking the "rules."

Remember that the more fluently you can execute the basic elements and combinations in all scales and orientations, the easier it will be for you to come up with just the right flourish when you need one. As it is with all rules, there will be exceptions to the suggestions in this chapter. Rules are made to be broken. But the ideas discussed here will give beginners a good basis by which to evaluate their work, and at the same time, a point of departure for more creative endeavors.

DESIGN SUGGESTIONS

The best preparation for creating an effective flourish is to have done many flourishes. Creative, perceptive and critical practice is invaluable. Jeanyee Wong once said, "To become a calligrapher, you must write many pages." This is just as true for flourishing. Jenny Groat's approach to a calligraphic project, Play, Plan, Practice, Perfect and Perform, is equally applicable to the design of flourishes, and will be expanded on here.

Play: Start by playing with the flourish; try some different ideas, combinations, arrangements. Enjoy the process; let your mind and your pen wander, frolic, doodle and discover! It can be fatal to become too serious too soon. While playing you may just hit on the idea or variation you've been looking for.

Plan: This is the time to do a serious evaluation of your ideas, pick out the most suitable ones and plan how they might fit into the piece you're doing. Use tracing paper and overlays to check on placement and size, and reevaluate the entire effect, returning to the Play phase if necessary.

Practice: Learn the flourish you've decided on, and practice it. Use the tools and materials you plan to use in the final piece. Remember that the beauty of calligraphy is in good measure based on spontaneity, and this will come with practice and confidence in your tools and materials.

Perfect: Now, perfect (i.e., make faultless) the flourish. Get it perfect, fluent,

confident and sure. You know how fluent and confident you are with the letterforms of the script you are writing; you should be as certain of any new flourish you plan to use as you are of your own handwriting.

Perform: Do the job! Perform it as a musician or a dancer performs. Remember that the "dance of the pen" really is a dance. The written marks of calligraphy are but the tracks and traces left by a performance, a concert of the physical and emotional dynamics of the calligrapher. When we view a piece of calligraphy that particularly moves us, we always feel these dynamics.

A FLUENCY EXERCISE

A good exercise to help develop fluency in flourishing is creating an alphabet of flourished capitals for an imaginary language. Just take your pen, and without trying to form any known letter, create a compact flourish that might be taken for a letter in some exotic script. Do as many different ones as you can and do them large enough to insure proper arm motion, say, one inch square or larger. Let the pen dance and see what happens (Fig. 44).

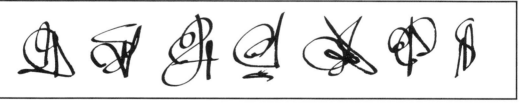

Figure 44. Doodles, squiggles, whatever you call them: random, unplanned flourishes can help open your creative mind and increase your fluency. They also make good warm-up exercises.

A FINAL WORD

After you've practiced the final flourish and have a perfect one on practice paper, it's always tempting to use it as an underlay on a lightbox or light table, and trace over it on the final sheet. This is usually a serious mistake. Tracing a flourish, or any

calligraphy for that matter, will usually result in a stiff, stilted caricature of the original. It is certainly possible and practical to use an underlay for guidance in position and size. However, when using an underlay in this way, take care not to trace the underlay. Use it only as an indication of where the flourish is to go. It takes a bit of practice and experience to be able to execute a flourish in this way and do it spontaneously without tracing it.

5
Applications of Flourishing

The world will not end with a bang, but with a flourish.
—with apologies to T. S. Eliot

GENERAL

Flourishes may be used for borders, patterns, ornaments and designs, to embellish text and decorate or ornament initial letters, to design cartouches, frames, logos, etc. Flourishing can provide excellent calligraphic therapy for improving your writing technique, while being just plain fun. After all, you don't have to worry about misspelling a flourish! Do keep a pad and a calligraphy pen near the telephone: flourishes make fine telephone doodles and many creative designs have been invented during a phone call.

BORDERS AND PATTERNS

A simple or a complex flourish, repeated along a line, can form the basis for a border. If the flourishes join, that is fine, but it is not necessary (see Fig. 45). Flourishes can also be used to create repeat designs to fill areas and backgrounds.

HEAD & TAILPIECES; SYMMETRY

These are essentially ornaments or short borders used at the top or bottom of calligraphic texts and chapters in books. Sometimes these are made symmetrical (mirror imaged) about a vertical axis. Symmetrical

Figure 45. Borders and patterns.

36

designs can be made by doing a flourish for one half and then tracing it on translucent paper. Turn the tracing over to get the mirror image half, and then practice both

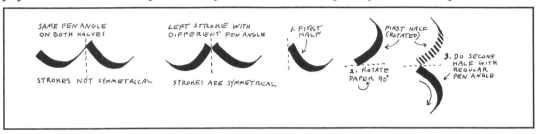

Figure 46. The 90 degree shift to obtain symmetry in the pen strokes.

halves before final execution. If you use the same pen angle for both halves, the mirror image half will look a little different from the first half. If you want an exact

mirror image representation, you must hold the pen edge at 90 degrees to the way you held it in the first half. This is easily accomplished by turning the paper 90 degrees from the original position (Fig. 46). Fig. 47 shows a symmetrical tailpiece that was done in this way.

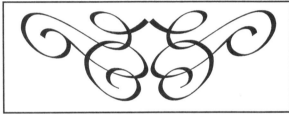

Figure 47. A symmetrical tailpiece.

One way of creating symmetrical flourish designs is to use a small rectangular mirror. Just do a flourish, and then hold the mirror with one edge against the flourish on the paper so that you can see the reflection of the flourish (Fig. 48). You will see a symmetrical design, half on the paper, and the mirror image in the mirror. By sliding the

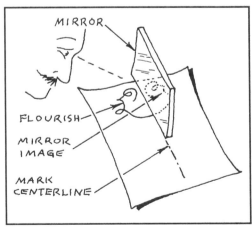

Figure 48. Symmetrical flourishes using a mirror.

mirror to different parts of the flourish, you can see many different designs and can choose the most applicable to your needs. When you have just the right one, draw a pencil line along the mirror edge. This locates the exact portion of the flourish to be traced and flipped over. This technique can be used to create symmetrical frames and cartouches as well, besides being lots of visual fun.

FURTHER USES OF SYMMETRY

The reflection or folding about a vertical (or horizontal) axis is only one kind of symmetry. Another kind is symmetry about a point. Rather than try to come up with a rigorous definition, we'll describe how to do it. For example, first draw the flourish as in Fig. 49 a. Then place a piece of tracing paper over it and trace the original flourish. Next, without moving the tracing, stick a pin in any part of the flourish and rotate the tracing through 180 degrees (two right angles) using the pin as a pivot. Finally, trace the original flourish onto the tracing paper to get the final design (Fig. 49 b). Just where you place the pin determines how the final design will look. Another example is shown in Figs. 49 c & d. It is not necessary to use a pin to do this: note that once the tracing has been rotated 180 degrees, it can be placed any-

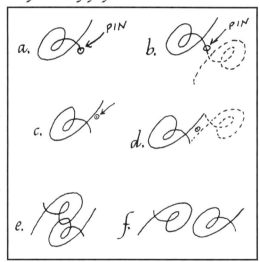

Figure 49. Symmetry about a point.

where with respect to the original, and the most appealing position used for the design (Figs. 49 e & f). Sometimes this technique will give you an idea for a new flourish combination, since the two halves are related but are not mirror images. With proper

positioning, the two halves may be joined to give the effect of a single line. The student should try this to see how it works.

The methods above give rise to designs with two related halves. Symmetrical designs with four related quarters are fun to consider, too. (Have patience, this is as far as we'll go with this subject.) There are essentially three kinds of symmetry that can be used here: 1) symmetry about a point; 2) symmetry about one axis or line; and 3)

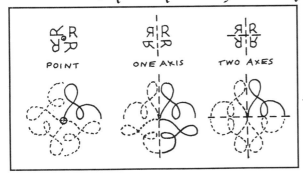

symmetry about two axes or lines at right angles to one another. Using the roman letter *R* to represent the flourish to be used as a basis for the design, the three methods are shown on schematic form in *Fig.* 50. There are many more variations of these symmetry schemes, e.g., repeating a

Figure 50. Three basic types of symmetry.

flourish around a point more or less times than four, or having more than two axes of symmetry. The basic methods developed here still apply.

AN ORNAMENTAL CAPITAL TECHNIQUE

An interesting ornamental capital can be made by repeatedly or continuously

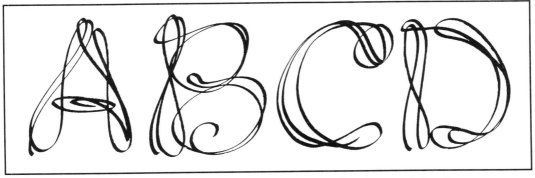

Figure 51. An ornamental capital technique using repeated or continuous flourishing over the basic letter structure.

flourishing over the imaginary skeleton of the letter with a rather narrow pen. The idea is easier to illustrate than it is to describe. The examples in Fig. 51 were each done with one continuous stroke.

ODDBALL PATTERNS & MISCELLANY

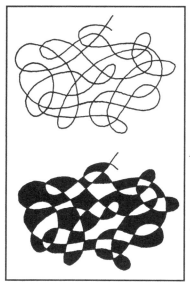

Figure 52. A pattern technique.

To generate interesting patterns for backgrounds or ornaments, try taking a rather dense complex flourish and fill in the white spaces with different colors or textures, or with black and white as in Fig. 52. If the flourish has no tangencies or multiple crossings, you should be able to alternate black and white with no ambiguities. This makes a great doodle during long phone calls!

Fig. 53 includes a selection of miscellaneous and "fun" flourishes that the author has created, cadged or copied over the years. They are included here for whatever use the student may find for them: inspiration, decoration, practice or just plain fun. The flourishes below that have no beginning or end were generally started near the top with a downward to the left stroke. Learning a few of these will do wonders

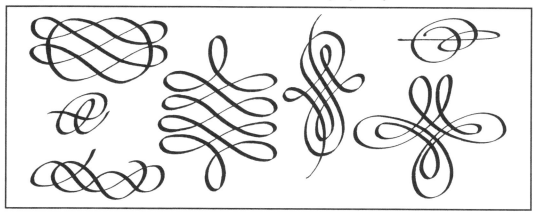

Figure 53. A collection of miscellaneous flourishes. (More on page 41.)

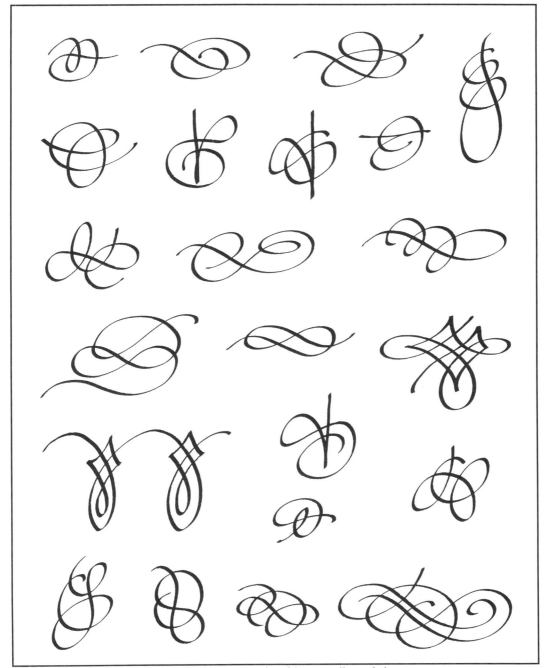

Figure 53. (Continued.) Learning a few of these is excellent right brain training.

for the right brain and your hand-eye coordination. It will be helpful to analyze the complex flourishes by writing a word description of each one using the nomenclature developed in Chapter 3.

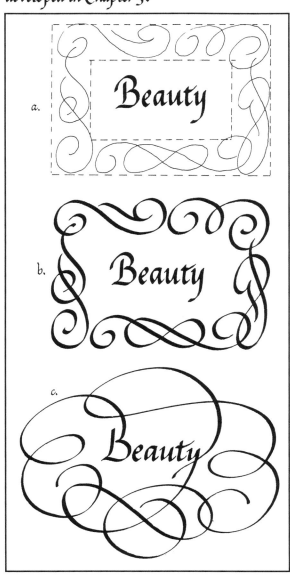

Figure 54. Frames.

CARTOUCHES AND FRAMES

Creating a flourish or flourish border around a name or title can be a challenge if it wants to appear as a spontaneously flourished affair rather than a carefully planned border. With experience these can be done without too much planning, but there are ways of approaching the problem that will get results without too much trial and error. First write the word or title the way it will appear, and then sketch the desired limits of the enclosing flourish in pencil. This area is then filled with one or more flourishes to suit. For reasonably formal frames, the flourishes can be sketched in pencil first (Fig. 54 a) and then finished in ink (Fig. 54 b). The appearance of spontaneity can be difficult to achieve when working within tight boundaries such as these. A less formal, more spontaneous frame is shown in Fig. 54 c. The

flourishes may be unconnected to the word enclosed, or they may connect to (emanate from) the word itself. When designing an enclosing flourish, careful consideration should be given to the amount of white space between the flourish and the words enclosed. Too little and the flourish will crowd the text; too much and the text and frame will not appear as a unit. If a symmetrical cartouche is desired, the methods of making a symmetrical flourish on pages 36 and 37 may be applied.

EMBELLISHING TEXT

Flourishes probably originated as the scribe completed the last word in a text and extended the last stroke of the last letter. Learning to flourish text involves learning how and where a flourish can be pulled from or added to a word or letter. Of course, a flourish need not be an extension of part of a letter, but can be added to a letter without being connected to it. More about this later. First we will consider just extending strokes. The Italic hand will be treated in some detail. The student can then apply the ideas developed to other alphabets.

THE ITALIC MINUSCULE

The beginning or end of any stroke in a letter can be extended and can be considered a "take-off" point for a flourish. These points can be categorized as entry points or exit points, and as ascender, descender, x-height or writing line points and are illustrated in Fig. 55. Note that descender flourishes are naturally exit flourishes and are

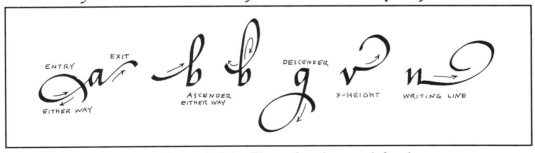

Figure 55. Showing the "take-off" points for Italic minuscule flourishes.

pulled away from the letter. Ascender flourishes would normally be entry flourishes and would be pulled toward the letter, but it would pay the student to learn to make these ascenders as push strokes also. This allows the letter to be located accurately in the word being written, and then the flourish can go sailing off with a lot more freedom (see the capital B in Fig. 54 c).

Letters such as f have four possible take-off points, but generally not all of them would be flourished. Some take-off points are not necessarily practical, e.g. the vertical stroke of the t as an ascending flourish. The letter t flourished in this way could be read as an f (Fig. 56). In general, flourishes should be checked to see that they don't impede the legibility or change the meaning of the text.

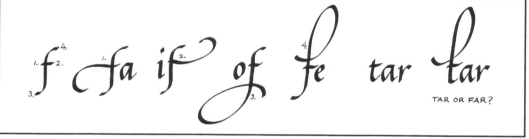

Figure 56. Some letters such as "f" have several take-off points.

Writing line, and x-height flourishes can be either entry or exit flourishes as shown (Fig. 57). Crossbar flourishes are essentially x-height flourishes and the "e"

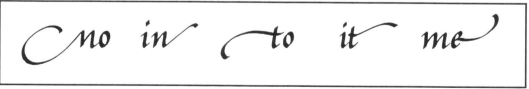

Figure 57. Entry and exit flourishes.

exit is sort of a half x-height variety. Entry flourishes can be written as you "go in" to the letter or can be added after the letter is written, and pulled away from it. Exactly how the flourish is connected to the take-off point is admittedly a small detail

but can make quite a difference in the appearance of a flourish and the direction it takes (Fig. 58). The student should take each letter of the alphabet and flourish each take-off point in turn, trying the different ideas discussed above.

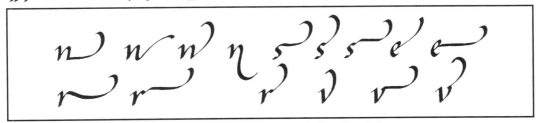

Figure 58. Several ways of connecting the flourish to the letter.

Some examples are given in Fig. 59. Note that the flourish forms part of the word from which it springs, and as such, due consideration should be given to the flourish's location with respect to the word, its density and its style. A flourish can cross over a letter or word if tastefully done. It should be noted here that a flourish doesn't have to be actually connected to a letter or word, but may be free floating and

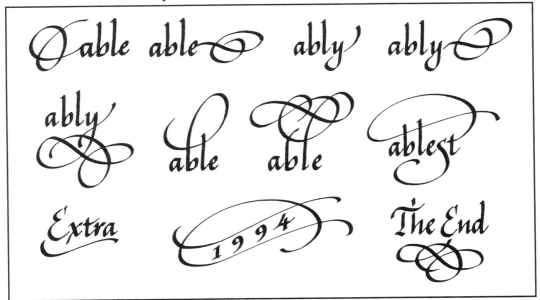

Figure 59. Flourishes applied to words.

still embellish the word. In fact, a flourish can form a line or framework on which lettering may be placed (e.g., the "1994" in Fig. 59). Remember, as with all decoration, usually less is more; don't overpower the text: complement it. If you have been practicing your forearm writing faithfully, you should be able to do exercises such as these with a 1 or 1.5 mm nib.

THE ITALIC MAJUSCULE

By now you should be able to recognize the possible "take-off" points in any calligraphic letter. Some of the possibilities for the capitals will be illustrated in Fig. 60. There are some points to be noted, however. In the A and M, a flourish loop is added in the letter construction proper. The first two Bs are made in one continuous stroke, resulting in pushed exit flourishes on top. The next B (in Bah) is also done in one stroke. Not all of the letters are represented; the examples shown will take care of most of the possibilities. Again the student is urged to work through the alphabet and try the different approaches, using each capital in a word as a practical example.

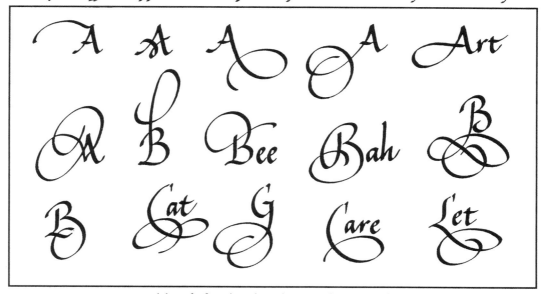

Figure 60. Some possibilities for flourishing the Italic majuscules. (More of Fig. 60 on next page.)

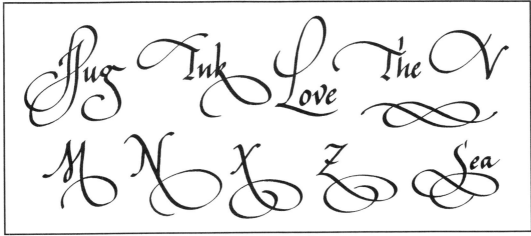

Figure 60 (continued).

POINTED PEN SCRIPTS

Pointed pen scripts, such as Copperplate and Spencerian, (as well as other broad pen scripts) can be treated with the approach above, but the pointed pen scripts have a few special features worth mentioning. The small letters can be treated in a manner similar to the Italic. However, it is the capitals that have some differences.

Copperplate and Spencerian capitals in their normal form are fairly well flourished to begin with. Good examples of these capitals are worthy of study to give an insight as to what makes a good flourish (Fig. 61). And flourishes can be added to them by

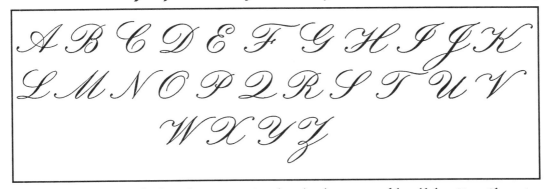

Figure 61. Copperplate capitals (from The Zanerian Manual, used with permission of the publisher, Zaner-Bloser, Inc. Columbus, Ohio, Copyright 1981).

extending strokes just as in the *Italic* (*Fig. 62*). Many of the Copperplate capitals begin with an entry loop flourish, but the decorative forms of the *Spencerian* caps generally have more complex and exciting flourishes (*Fig. 63*). A great many of these became rather standardized during the ornamental penmanship era (c. 1870 to 1920) and a thorough study of them may be found in Michael Sull's excellent book "*Spencerian Script and Ornamental Penmanship.*" Some additional examples of pointed pen flourishes may be found in Chapter 9.

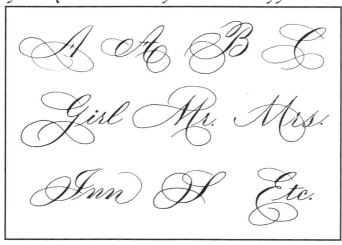

Figure 62. Examples of flourished Copperplate capitals.

THE GOTHIC SCRIPTS

The treatment of flourishing the Gothic scripts will be delayed until two other subjects are developed: 1) the so-called appended flourish and 2) cadels. These follow in Chapters 6 and 7.

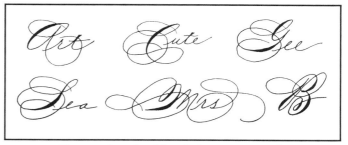

Figure 63. Examples of flourished Spencerian capitals.

OTHER SCRIPTS

The basic principles developed so far can be applied to adding flourishes to other scripts, such as uncial, rustic, humanistic minuscule (bookhand) and even such letterforms as *Neuland*. If you want to have your flourishes in keeping with tradition,

be sure to study historic examples to see what kind of embellishment was used. If you want to be creative, study the characteristics of the script in question and design your flourishes to harmonize (or at least cooperate) with the script.

FLOURISHING LONGER TEXTS

The use of flourishes, whether with single words, logos, short phrases, poetry, or longer prose texts, is a matter of taste. Styles can range from conservative to flamboyant. Whether a piece has one single swash, or explodes with flourish fireworks, if executed with taste and freedom, it can be effective. During the Baroque period much work was over ornamented, and a lot of calligraphic work was covered with curly flourishes crawling between the lines (Fig. 64). But if this suits the mood of your work, there is no reason not to try it.

A more conservative treatment is generally best when working with longer texts. A flourished capital at the very beginning, or perhaps at the start of each paragraph, and

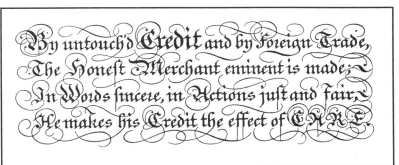

Figure 64. A little over-ornamentation (from *The Universal Penman*, engraved by George Bickham, reprinted by Dover Publications, N.Y. 1941).

perhaps a flourish at the very end, will usually be sufficient. A solid block of text will have room in the margins (top, bottom, and sides) for flourishes, without disturbing the integrity of the text block itself. Keep in mind that flourishes can be great as "attention getters" but care should be taken that they enhance the text and do not detract from it.

6

The Appended Flourish

If at first you don't succeed, add a flourish.
—Anon.

BASICS

Up to this point we have treated a flourish as either a stand alone ornament or as an extension of a letter stroke. Here we will look at flourishes from a completely different point of view, i.e. by adding or appending strokes to letters or to other flourishes, and we will consider the different ways the added stroke relates to the original. As in all calligraphy, it is not just the appearance of the stroke itself that matters, but also its location and spacing with respect to other strokes. There are basically five ways of appending strokes: 1) continuation; 2) paralleling; 3) opposition; 4) dash & diamond; 5) darts, dots & fishtails. These are illustrated in Fig. 65, where the flourish is shown added to a simple s-shaped main stroke.

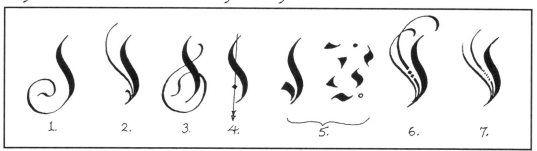

Figure 65. The appended flourish: 1. continuation; 2. paralleling; 3. opposition; 4. dash & diamond; 5. darts, dots & fishtails; 6. & 7. showing that flourish strokes can be interrupted.

Some of these ideas will somewhat overlap the work already covered. For example, continuation is the same as extending a stroke, except that previously we extended the stroke as it was being written, and here we will also consider adding the continuation after the main stroke has been finished; thus the name, appended flourish. This

allows the use of a different pen (usually a finer one) for the appended flourish, as shown in the examples. A finer stroke can sometimes be pulled away from the main stroke with the corner of the same pen, but with today's steel nibs this doesn't always work well. During the Baroque period quill pens were used, and for this use they were split off center. This would allow fine lines to be pulled away from a broad stroke without even lifting the pen, just tipping the nib on the corner nearest the slit.

The second type, paralleling, runs the added stroke along the side of the main stroke. Sometimes the added stroke remains the same distance from the main one (as if it were an outline) but more often it gradually strays away and ends in a flourish. The opposition idea takes a separate flourish stroke and places it so it opposes (crosses) the main stroke. The dash and diamond (also known as the stroke and dagger) is a form of paralleling but is always a straight line, usually but not always vertical, usually thin, and sometimes ending or beginning with a diamond. It is used to decorate straight strokes or contrast with curved strokes. Darts, dots and fishtails are just small free floating decorations added to a flourished or ornamented letter. When applying these principles, the ideas developed in Chapter 4 relative to the control of white space, ambiguity, etc., should still be taken into consideration.

TEXTURA AND FRAKTUR

Appended flourishing became popular during the Renaissance and was used to embellish Gothic scripts such as Textura and Fraktur. Textura and Fraktur capitals are good examples of inherently flourished letters (Fig. 66) since they depend on

Figure 66. Textura (left) and Fraktur (right) capitals are inherently flourished in their normal form.

appended flourish strokes for their basic form. In fact, the Fraktur alphabet as used during the Baroque period is probably the only western book script with the freely flowing lines that occur in the scripts of the Middle East.

Along with the appended flourish comes the interrupted stroke. This is not a flourish itself, but a way of modifying a flourish stroke or regular letter stroke. Some simple examples of appended flourishes and interrupted strokes are shown in Fig. 67.

Figure 67. Showing how the appended flourishes and interrupted strokes are used.

During the Baroque era the masters of this style carried the ornamentation of Fraktur capitals beyond the limits of readability and into the realm of pure texture and design (Fig. 68). However the method was rather simple. After the main strokes of the letter were done, the appended flourish principles were applied either with progressively smaller broad nibs or with a pointed nib to fill the white spaces to

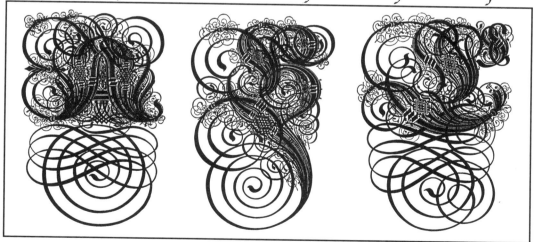

Figure 68. Highly flourished Fraktur capitals, A, B, and C, from 1601 (from "Decorative Alphabets & Initials," Alexander Nesbitt, Ed., Dover Publications, N.Y. 1959).

an even color (density.) The strategy involves making the first two or three flourish strokes work interestingly with the letter's strokes, using both paralleling and opposition to create an engaging pattern. The main strokes of the letter receive these first flourish strokes. Then these are followed with finer pen strokes until the desired density is achieved. The examples in Fig. 69 illustrate this technique.

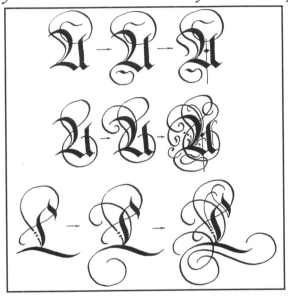

Figure 69. Appended flourish examples: Top: a capital A with four appended strokes (the student should copy this example about 1.5 inches high and finish it as an exercise;) Middle: a finished capital A; Bottom: a finished capital L.

One of the great Baroque writing masters, Wolffgang Fugger, developed five ways of flourishing the main stroke of a Fraktur capital so as to form the basis for an ornamented capital. These are shown in Fig. 70 on page 54. A few of the letters are fully flourished to illustrate the approach. Students who are familiar with the Fraktur capitals should first try to build a complete alphabet using the main flourish stroke and then proceed to ornament the letters with flourishes.

Fugger's Handwriting Manual was reprinted by the Oxford University Press in 1960, but it is not easy to find.

FRAKTUR CAPITALS

These flourished Fraktur capitals make very intriguing initial letters and this style formed the basis for American Type Founders' Dutch Initials type font (c. 1900) shown in Fig. 71 on page 55. The letter B is enlarged in Fig. 72, and annotated to show the application of the appended flourish principles. For comparison, an

Alternate Capital Forms which are adaptable to flourishing~from Wolffgang Fugger

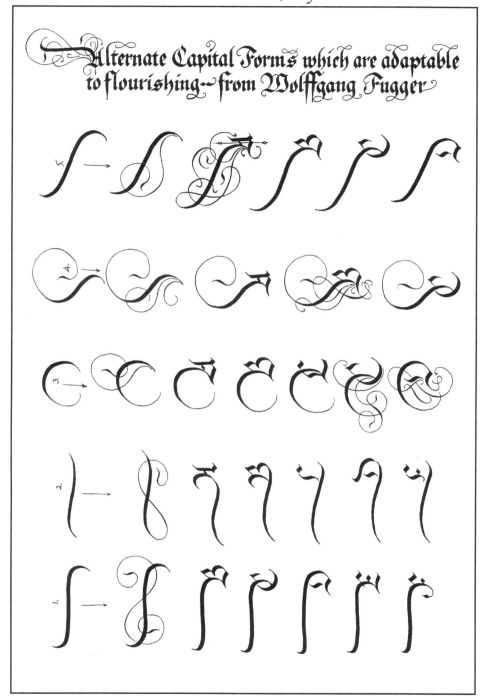

Figure 70. Five flourish strokes on which to build an alphabet of Fraktur capitals. Each column shows the prototype stroke at the top followed by a possible appended flourish. Next come some letters built using the prototype stroke, a few of which are finished to illustrate the process. The student should try completing one or more of the alphabets as an exercise. (Adapted by the author from Fugger's "Handwriting Manual," Oxford Univ. Press, 1960)

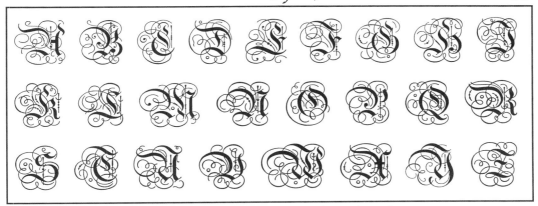

Figure 71. American Type Founders' Dutch Initials type font.

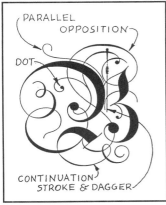

Figure 72. Enlarged "Dutch" B.

ornamented Fraktur alphabet from "The Universal Penman" of 1743 is shown in Fig. 73. Both of these alphabets are excellent examples of the application of the appended flourish and it will pay the student of flourishing to study them carefully.

The student should experiment with the use of these principles on Textura and Fraktur letters as well as on Roman capitals. An example of this approach used on Roman capitals from the Victorian era is reproduced in

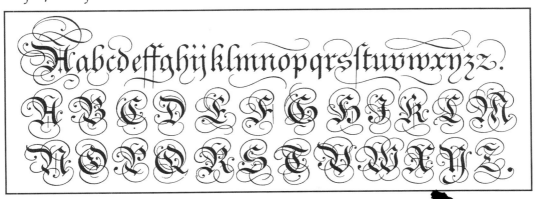

Figure 73. A flourished Fraktur alphabet from "The Universal Penman," Bickham, op. cit.

Fig. 74. The ideas here can easily be adapted for contemporary use.

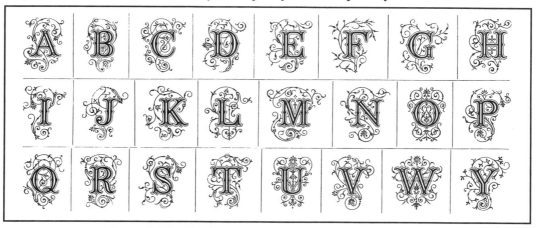

Figure 74. The appended flourish technique used on Roman capitals from a Victorian era type font.

THE DOUBLE STROKE

Though this is not strictly a flourishing technique, it does relate to the paralleling technique and will lead to a consideration of the cadel flourish. The double (or multiple) stroke idea is to write or build the thick strokes of a letter using two or more strokes. In itself, this is a nice way to make an initial letter, and we can also apply

Figure 75. Double and multiple stroke techniques. The third B shows a double stroked copperplate letter.

the interrupted stroke idea as an embellishment (Fig. 75). A multiple stroke capital can be ornamented by adding appended flourishes with a finer pen (Fig. 76).

The main stroke of a multi-stroke capital can be further enhanced by weaving or knotting or braiding the strokes as in Fig. 77. The examples labeled cadel work are interesting because they show the relation of this type of ornamentation to curvilinear

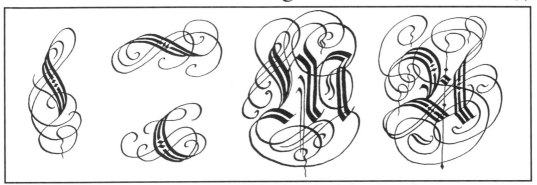

Figure 76. Combining appended flourishes with multiple stroke capitals.

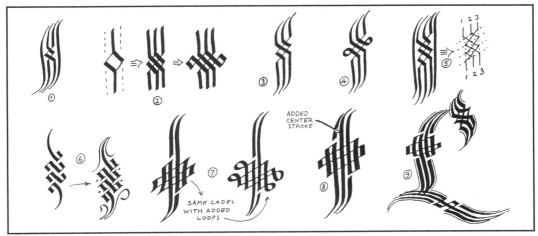

Figure 77. Weaving and braiding multiple strokes: 1. & 2. woven strokes; 3. 4. & 5. braided strokes; 6. another woven stroke; 7. & 8. cadels with added strokes; 9. capital L using cadel and woven strokes.

flourishing and (believe it or not) Celtic knot work. This relationship is illustrated in Fig. 78. Cadels will be treated fully in Chapter 7.

Figure 78. The flourish-cadel-Celtic knot relationship.

FLOURISHES AND KNOTS

Before we begin the study of cadels, it is interesting to note the relationship between knots and flourishes. If we trace through a Celtic knot, for example, we find that our trace will alternately cross over and under other sections of itself. Satisfying

this over and under rule is a requirement for Celtic knots. Now consider a random complex flourish as in *Fig. 79*. As long as the two ends of the flourish are in the same white space (i.e. both ends come out of the flourish) then the flourish satisfies the over and under rule, and can be considered a knot.

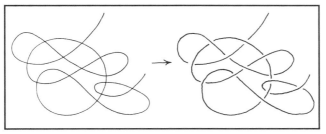

Figure 79. Demonstrating the flourish-knot equivalence.

Figure 80. 15th century Italian White Vine work as interpreted by the author.

FLOURISHES & VINEWORK

Flourishes, knots and vinework decoration are also related in a similar way. Vinework is usually laid out by drawing the main branches of the vine as graceful flourish strokes, using the principles of paralleling and opposition to create visual interest. More branches are added to fill in white areas, keeping the white spaces fairly equal, and finally flowers, fruit and leaves are put in. The vines are inked and cross overs are alternated over and under to the best of the artist's ability, although this is not always possible, or even necessary. The vines and foliage are traditionally left white while the initial letter is gilded and the background spaces are colored in. An example in the 15th century Italian White Vine style is shown in *Fig. 80*.

7
The Cadel Flourish

There once was a scribe named Rousseau,
Who was writing a complex cadeau,
When just half way through,
He exclaimed, "Oh, mon Dieu!"
"My pen knows not which way to go!"
—Guillermo Ildebrando

INTRODUCTION

The word cadel, (also cadeau, which is French for "gift") is used to describe a flourish made up primarily of relatively straight sections joined by angular or square corners, rather than curves based on ovals and circles. This type of embellishment can be traced to the kinds of flourishing found in early charters when, in response to the Gothic influence, documentary scripts began to become angular as did the associated curvilinear flourishes. The technique reached its height during the 15th century and was used both in manuscripts and for the design of many decorative initial blocks in early printed books.

Cadels were used with the Bastardas, Frakturs and other Gothic scripts to add weight to an open letter, to show off the technical prowess of the scribe, and to add

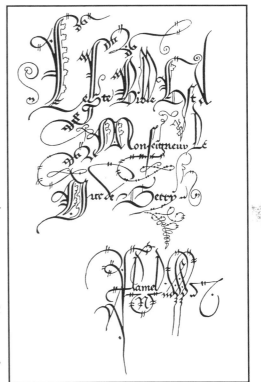

Figure 81. Cadel inscription by Nicolas Flamel, c.1400. (From "Alphabets and Ornaments," by Ernst Lehner, Dover Publ. 1952.)

59

sparkle to the text. For the contemporary calligrapher, cadels also add zest to such scripts as Edward Johnston's Pointed Italic and "Gothicized Italic." An example of the technique in an inscription by Nicolas Flamel c. 1400 is shown in Fig. 81, and some woodblock initials of Christopher Plantin in the cadel style are reproduced in Fig. 82. If you trace through the letter *A* you will find that it has two separate parts whereas the *B* has only one continuous line. A common tour de force was to design a capital with cadel techniques so that it could be written with one continuous stroke without the pen leaving the paper. Incidentally, the art of doing a flourished capital, bird or other figure in one continuous stroke was known as "striking." Thus today we occasionally hear the phrase "to strike a flourish" meaning to execute the flourish with dash and élan.

Figure 82. Examples of 16th century cadel initials from "The Woodcut Initials of Christopher Plantin" by Stephen Harvard, published by The American Friends of The Plantin-Moretus Museum, 1974; reproduced with the permission of Stephen Harvard, and The American Friends of the Plantin-Moretus Museum.

UNDERSTANDING CADELS

A good way to start is to compare simple curvilinear flourishes with their cadel equivalents. Compare the s-curve with its cadel form in Fig. 83. The direction of the cadel stroke is either along the hairline direction or (more or less) at right angles to it. Study the other cadel equivalents shown in the figure; try some with your broad pen. Note

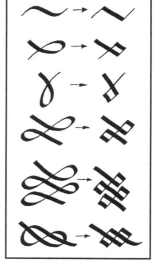

Figure 83. Cadel equivalents.

that the pen angle used is approximately 45 degrees, although this can vary depending on the design. Most simple cadels can be expanded into families of increasing complexity and decorative quality. Even the simple loop can be expanded into a series of

intriguing cadels, as shown in Fig. 84. The curvilinear equivalents of these are not very interesting as you will discover if you try drawing them out.

A DEFINITION

Let us define a true cadel as one which can be traced completely from one end to the other with a single line without retracing any part, where the trace may

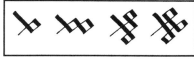

Figure 84. The simple loop as a cadel.

Figure 85. Illustrating true and false cadels.

cross itself only once at any crossing point, and where the trace must cross any line in the pattern that it touches. A false cadel does not satisfy this single line requirement. Some examples illustrating this definition are shown in Fig. 85. The purists in the Baroque era insisted on true cadels but much good work was done with false cadels (i.e. with multiple traces) and there is no great reason to avoid them.

DIAGRAMS VS. EXECUTION

A good way to learn cadels is to study them in diagram form. For a diagrammatic representation we will use monotonic lines and right angles, with all lines either horizontal or vertical, as though laid

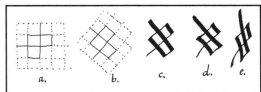

Figure 86. Cadels: diagrams vs. execution.

out on a rectangular grid. This makes it easier to see and understand the pattern structures. However, cadels are actually written with a broad pen with strokes generally at an angle of 45 degrees (more or less) with the writing line, and a diagonal or diamond pattern grid is used as shown in Fig. 86. The dramatic effect of a cadel can also be heightened by making the straight strokes slightly curved as shown in part d of Fig. 86. In part e the grid is compressed horizontally to add to the dynamic effect.

CADEL FAMILIES

Most relatively simple looking cadel figures can be expanded into families of increasing complexity, where each new member generated depends on the structure of the

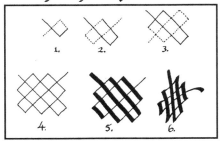

Figure 87. 1, 2, 3, and 4 are the first four members of a cadel family. 5 shows the fourth member done with the broad pen, and 6 shows how it would be done in practice.

original, or parent, and the application of a unique sequence of "moves." It sounds complicated, but tracing through the example in Fig. 87 will illustrate the idea far better than words. In each example, the move sequence used to generate successive members of the family should be worked out by the student. Trying to give a strict word description (or formula) would be complicated and not very helpful.

In this example (Fig. 87) half the pattern is drawn dotted in the rectangular grid to show that the

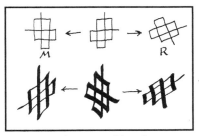

Figure 88. The center cadel with its mirror image on the left and its rotated image (about 45 degrees clockwise) on the right. Below are their pen renditions.

pattern comprises two similar structures superposed. When you have become familiar with a pattern, try rotating it, i.e., drawing it in different orientations; also try drawing its mirror image (Fig. 88). This will show that many different looking patterns are actually the same except for rotation or mirroring.

Sometimes a family will generate false as well as true cadels (Fig. 89). It can be shown that the appearance of a false cadel in a series can be predicted

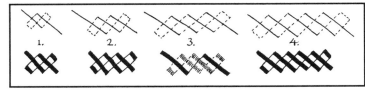

Figure 89. This cadel family will periodically generate a false cadel. The upper row shows the method of construction. Member 3 is a false cadel. The second part in its pen rendition (bottom) is shaded to show it does not connect to the first part.

once the "formula" for the series is determined, e.g. see page 71. To understand each family, the student should draw out the series with pencil, and then do the same series with the broad pen, using an angular grid to see how the members look in practice. To really understand each series, the student should try to generate the next one or two members of that series.

For those who like puzzles and mazes, a few more cadel families are developed in Fig. 90. Notice that each member of family B is a false cadel. A more extensive catalog of cadel families will be found in Chapter 8.

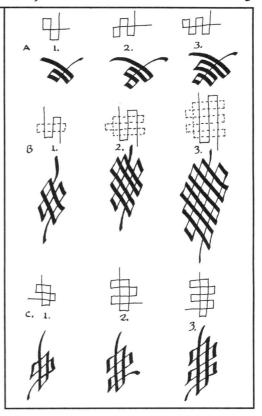

Figure 90. Three more cadel families. Family B yields only false cadels. (The second trace is shown dotted.)

ADDING LOOPS, ETC.

Any cadel may be enlarged or enhanced by adding loops to the outside corners as in Fig. 91. These may be angular or curved depending on the effect desired. In addition, most cadel patterns can be closed by joining the two ends to make a stand alone ornament, or they can be "opened" to give four or more ends so they may be inserted into double stroke capitals or joined to form borders, etc. In the case of borders, the analogy to Celtic knotwork becomes obvious as shown in Fig. 92 on page 64.

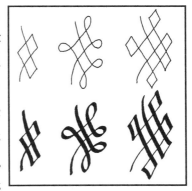

Figure 91. Adding loops. The simple cadel (left) with loops added (right.)

A COMBINED TECHNIQUE

Cadel and curvilinear techniques may be combined in a given flourish to give interesting results (*Fig. 93*). The student should experiment with the different families to see how changing some loops to curves changes the effect of the flourish. Just as a curved loop or two can be worked into a cadel flourish, the student can consider adding a cadel-like angle to ordinary curvilinear flourishes.

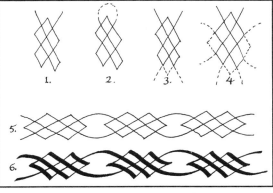

Figure 92. Closing and opening cadel patterns.

Figure 93. Combining curvilinear flourishes with cadels.

SOME SIMPLE APPLICATIONS

The parallel stroke characteristic of cadels can be used to embellish letters and text without using complex patterns. Complex patterns are fun as perceptual exercises and are useful in borders, patterns and cadel capitals, but the simple strokes are best for text ornamentation. Some examples are shown in *Fig. 94* on page 65.

BUILDING CADEL CAPITALS

Cadel capitals may be constructed in several ways. One can base the letter on a double or triple main stroke to which cadels are added, or the entire letter may be made up of cadel patterns. A capital "*L*" is developed step by step in *Fig. 95* on page 66. Designing capitals such as these requires a bit of pencil layout before ink drafts are made. The attraction of these capitals lies in their even white space distribution. A number of historical examples are given in *Fig. 96* on page 66. These should be analyzed carefully by the student. Notice that many of these require some pen edge

or pointed pen work for their execution. Fig. 97 on page 66 outlines the steps one might use in analyzing the complex cadel capital D from Fig. 96. The process involves drawing the cadel in pencil, identifying added loops, if any, and redrawing the pattern on a rectangular grid, changing curvilinear loops to square-edged ones in the process. Studying cadels in this way is a great help in understanding the structure prior to adapting the cadel or designing your own. A catalog of cadel forms collected over the years will be found in Chapter 8 on page 68. This catalog documents some of the mathematical qualities of cadels and is a handy table of standard forms.

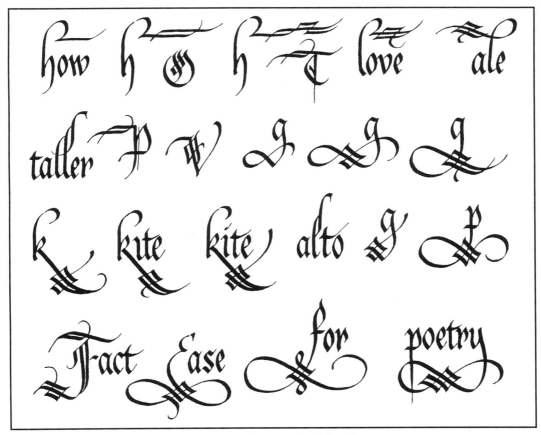

Figure 94. Applications of cadel flourishes.

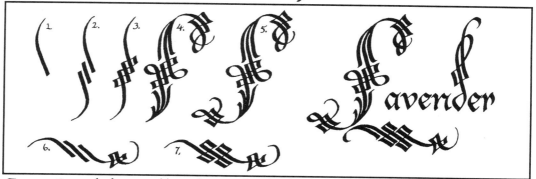

Figure 95. Steps in developing a cadel capital. Steps 1 through 5 show how the main stroke is developed. Steps 6 & 7 show the construction of the horizontal stroke separately.

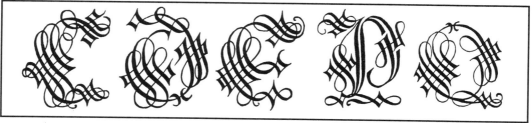

Figure 96. Some more cadel capitals from "The Woodcut Initials of Christopher Plantin" by Stephen Harvard, published by The American Friends of The Plantin-Moretus Museum, 1974; reproduced with the permission of Stephen Harvard, and The American Friends of the Plantin-Moretus Museum.

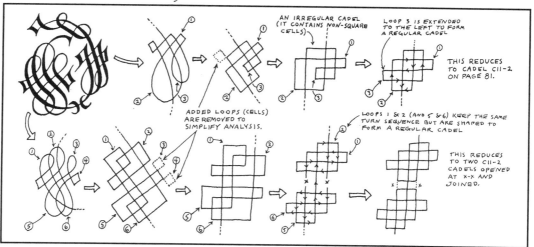

Figure 97. An analysis of the cadel capital D from Figure 96. The pattern is sketched and redrawn on a rectangular grid. To relate the pattern to a standard form, added loops are removed, and irregular cadels (those containing non-square cells) are modified by stretching or shrinking cells while maintaining the same turn sequence. (See also pages 68 and 69.)

A WORD TO THE WISE

A final but important thought: if a flourish doesn't look right in a piece, do the piece over and leave out the flourish. "Less is more." But do not deny yourself the pleasure of flourishing. For every flourish I've included in a piece, there are hundreds that I have thrown away, but what fun they were! (Actually, I never throw away a flourish. I save them. I have three trunks full in the attic and I have instructed my heirs to have them published after I myself have ceased to flourish.)

The study of flourishing, and calligraphy in general, can be an endless task, or it can be a lifetime of love, depending on how you look at it.

A calligrapher named Sally Wright,
After flourishing night after night,
Concluded, guess what:
Like a true Celtic knot,
That there really was no end in sight.

—Guillermo Ildebrando

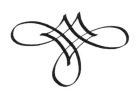

8

A "Cadelogue"

Jack be nimble, Jack be quick,
Here are the cadels, take your pick!

GENERAL

This collection comprises a number of cadel families presented in diagram form. It is by no means exhaustive but it can be helpful to the student in learning and recognizing certain forms. Each family is shown with enough members so that the family structure can be discerned. Although not all of the families will be of interest to the cadel student, they can be useful as border elements and as knotwork patterns. Along with each family are broad pen rendered examples. These cadels are what might be termed regular cadels, in that they exhibit a certain symmetry or regularity. Many of the cadel patterns in the more intricate examples from the Baroque period are irregular in form and are not covered in this collection.

For those interested in the mathematical integrity of these families, a few definitions are in order. As we did in Chapter 7, we will define a true cadel as one with two ends, which can be traced completely from one end to the other with a single line without retracing any part, where the trace crosses itself only once at any crossing point, and where the trace must cross any line in the pattern that it touches. (This last condition precludes tangent points.) A false cadel does not satisfy this single line requirement, but that is no reason not to use it in your work.

This collection will have both true and false cadels in it. A false cadel will comprise a true cadel with one or more true cadels (secondary traces) superimposed on it (i.e. drawn over it) in such a way that there are no tangent points and that no more

68

than two lines cross at any crossing. To simplify the formulas which will be developed, these secondary cadels will be limited to closed cadels which have no ends.

There are certain features of cadels that can have numerical values, and we will see how these help in understanding the idea of cadel family. These features are best defined visually as in Fig. 98. A cadel, in idealized form, is drawn on a rectangular grid with a number of straight strokes connected by right angle turns. We will call the number of strokes in a cadel s. The trace of the cadel will start outside the pattern, cross itself (or its secondary parts) a number of times and will end outside the pattern. The trace will define and enclose a number of boxes or cells. Cadels with cells that are square and of equal size are called regular cadels. Cadels with at least one non-square cell are termed irregular. A cadel with no ends is called closed and a cadel with ends is called open. Open cadels always have an even number of ends.

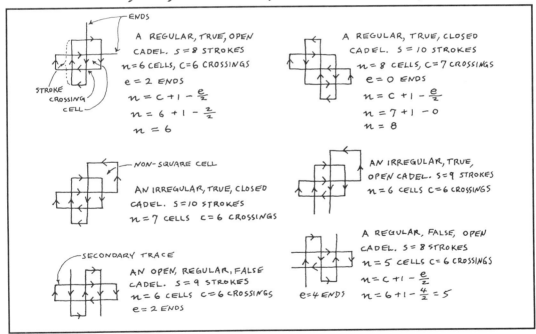

Figure 98. Illustrating the definitions given in the text.

The number of crossings in a cadel pattern will be called c and the number of cells will be called n. In an open cadel with two ends the number of cells equals the number of crossings (n = c). In general the number of cells will equal one more than the number of crossings reduced by one half the number of ends. These ideas and definitions should be reviewed by studying Fig. 98 on page 69.

The relation between c, n, and the number of strokes, s, is more complex and will depend on the structure of the particular family. This relation has been derived for a number of the families which follow. In each family we will number the members consecutively in order of increasing complexity, and we will call this number k. (The formulas for s and n in terms of k are given for each family. The formula for c is the same as for n, since c = n for open cadels with two ends.) The families themselves will be numbered consecutively for identification purposes, without regard to their particular structures.

It should be noted that members of each family may be mirror imaged (flopped) or rotated without changing the characteristics of the family. A few of the more complex cadels have direction arrows added to aid in tracing the patterns. The Cadelogue which follows on page 71 is not claimed to be exhaustive or complete, but is intended to be introductory and illustrative of the structure of these patterns.

Cadel Family C1

Family Member k	No. of Cells n	No. of Strokes s	Cadel Pattern	Notes & Applications
1	1	4		
2	2	5	FALSE (2 PARTS)	ADDED LOOPS
3	3	6		
4	4	7		
5	5	8	FALSE	
6	6	9		BOTH C1-6
7	7	10		ADDED ROUNDED ADDED ROUNDED
8	8	11	FALSE	BOTH C1-8 — MODIFIED BY ADDING LOOPS
9	9	12		If $\frac{n+4}{3}$ = a whole number then the cadel has 2 parts — i.e. is false.
	n=k	s=k+3		

Cadel Family C2

Family Member k	No. of Cells n	No. of Strokes s	Cadel Pattern	Notes & Applications
1	3	6		
2	6	8		
3	9	10		OPEN & ADD LOOP TO USE AS BORDER
4	12	12		SIMILAR TO ABOVE BUT ENDS ARE JOINED
5	15	14		AN AID TO CONSTRUCTING LARGER PATTERNS: START WITH 2 CELLS:
6	18	16		ADD ANY NUMBER OF GROUPS OF THREE:
				THEN END WITH ONE CELL CENTERED ON THE LAST GROUP OF THREE.

$$s = 2k + 4$$

$$n = 3k$$

Cadel Family C3

Family Member k	No. of Cells n	No. of Strokes s	Cadel Pattern	Notes & Applications
1	12	11		
2	16	13		
3	20	15		
4	24	17		A CONSTRUCTION AID:
			$s = 2k + 9$	
			$n = 4k + 8$	ANY NUMBER OF GROUPS OF FOUR CELLS.

Cadel Family C4

Family Member k	No. of Cells n	No. of Strokes s	Cadel Pattern	Notes & Applications
1	1	4		
2	3	6		*
3	6	8		
4	10	10		
5	15	12		
6	21	14		TRY MAKING ALL CORNERS ROUND—.
7	28	16		

$$s = 2k + 2$$
$$n = \tfrac{1}{2}k^2 + \tfrac{1}{2}k$$

✻ #2 IS THE FAMILIAR OVERHAND KNOT →

Cadel Family C5

Family Member k	No. of Cells n	No. of Strokes s	Cadel Pattern	Notes & Applications
1	3	6		
2	8	10		CLOSED
3	15	14		
4	24	18		
5	35	22		

$$s = 4k + 2$$

$$n = k^2 + 2k$$

✱NOTE: ALL EVEN NUMBERED MEMBERS MAY BE CLOSED TO YIELD A SYMMETRICAL FIGURE.

Cadel Family C6

Family Member k	No. of Cells n	No. of Strokes s	Cadel Pattern	Notes & Applications
1	1	4		
2	3	6		
3	5	8		
4	7	10		
5	9	12		
6	11	14		
7	13	16		

$$n = 2k-1 \qquad s = 2k+2$$

Cadel Family C7

Family Member k	No. of Cells n	No. of Strokes s	Cadel Pattern	Notes & Applications
1	2	6		ADDED CELL
2	5	8		
3	8	10		CLOSED
4	11	12		
5	14	14		
6	17	16		

$$n = 3k - 1$$
$$s = 2k + 4$$

Cadel Family C8

Family Member k	No. of Cells n	No. of Strokes s	Cadel Pattern	Notes & Applications
1	4	7	PART 2 ← / PART 1 ←	CLOSED
2	10	11		
3	16	15		
4	22	19		
			$n = 6k - 2$ $s = 4k + 3$ THIS IS A FALSE CADEL OF TWO PARTS.	A BORDER:

Cadel Family C9

Family Member k	No. of Cells n	No. of Strokes s	Cadel Pattern	Notes & Applications
1	6	9	← PART·2 ← PART 1	
2	14	13		
3	22	17		
4	30	21	$s = 4k + 5$ $n = 8k - 2$ A TWO PART FALSE CADEL.	
			RELATED FAMILIES NOT DEVELOPED IN DETAIL: → → ↓ → ETC... ↓	

Cadel Family C10

Family Member k	No. of Cells n	No. of Strokes s	Cadel Pattern	Notes & Applications
1	2	7		REPEATED → (SEE ALSO C15–1)
2	10	11		
3	18	15		
4	26	19		
			$s = 4k + 3$ $n = 8k - 6$ #2 WITH AN ADDED STROKE DOWN THROUGH THE CENTER PLUS FALSE SIDE STROKES	

Cadel Family C11

Family Member k	No. of Cells n	No. of Strokes s	Cadel Pattern	Notes & Applications
1	4	7		
2	12	11		
3	20	15		
4	28	19		

$$s = 4k + 3$$
$$n = 8k - 4$$

#1 IS THE FAMILIAR FIGURE-8 KNOT ⟶

* WORKS NICELY WITH ONE CELL ROUNDED:

Cadel Family C12

Family Member k	No. of Cells n	No. of Strokes s	Cadel Pattern	Notes & Applications
1	6	11		THIS IS TWO C4-2 CADELS JOINED.
2	14	15		
3	22	19		
4	30	23		

$$s = 4k + 7$$
$$n = 8k - 2$$

#1 AS A "HEART" BORDER

Cadel Family C13

Family Member k	No. of Cells n	No. of Strokes s	Cadel Pattern	Notes & Applications
1	12	15		
2	24	19		
3	36	23		
4	48	27		

$$s = 4k + 11$$

$$n = 12k$$

Cadel Family C14

Family Member k	No. of Cells n	No. of Strokes s	Cadel Pattern	Notes & Applications
1	8	11		
2	16	15		
3	24	19		
4	32	23		

$$s = 4k + 7$$
$$n = 8k$$

Cadel Family C15

Family Member k	No. of Cells n	No. of Strokes s	Cadel Pattern	Notes & Applications
1	4	11		
2	16	15		
3	28	19		
4	40	23		
			$s = 4k + 7$ $n = 12k - 8$	#1 REPEATED ↗ (COMPARE WITH C10-1)

Cadel Family C16

Family Member k	No. of Cells n	No. of Strokes s	Cadel Pattern	Notes & Applications
1	1	4		
2	2	6		
3	3	8		
4	4	10	$s = 2k + 2 \quad n = k$	

Cadel Family C17

k	n	s		
1	4	7		
2	8	11		
3	12	15		
4	16	19	$s = 4k + 3 \quad n = 4k$	

Cadel Family C18

Family Member k	No. of Cells n	No. of Strokes s	Cadel Pattern	Notes & Applications
1	1	4		
2	2	6		
3	3	8	$n = k \quad s = 2k+2$	

Cadel Family C19

k	n	s		
1	5	8		
2	11	12	$n = 6k-1$ $s = 4k+4$ A TWO PART FALSE CADEL WITH A NON-SQUARE END CELL.	MANY VARIATIONS POSSIBLE BY OPENING, CLOSING, ETC.

Cadel Family C20

Family Member k	No. of Cells n	No. of Strokes s	Cadel Pattern	Notes & Applications
1	8	11		
2	14	15		
3	20	19		

$$s = 4k+7 \quad n = 6k+2$$

A TWO PART FALSE CADEL WITH NON-SQUARE END CELLS.

NOTE HOW CADELS MAY BE EXPANDED BY ADDING CELLS

Cadel Family C21

Family Member k	No. of Cells n	No. of Strokes s	Cadel Pattern	Notes & Applications
1	10	12		
2	16	16		
3	22	20		
4	28	24	$s = 4k + 8 \qquad n = 6k + 4$	
			#1 TURNED UPSIDE DOWN AND VARIED BY ROUNDING SOME STROKES, ADDING CELLS, ETC.	THIS ONE IS USED AS THE TAILPIECE FOR CHAPTER 7, PG. 67.

Cadel Family C22

Family Member k	No. of Cells n	No. of Strokes s	Cadel Pattern	Notes & Applications
1	3	6		
2	10	12		
3	21	18		

$s = 6k$, $n = 2k^2 + k$ (compare C5)

Cadel C 21-1 on page 89 grew out of a telephone pad doodle that led to the tailpiece used on page 67. The evolution of this flourish is shown in Fig. 99 a. This pattern itself can form the basis of a family of related flourishes with increasing numbers of loops (Fig. 99 b).

Figure 99. a: The evolution of Cadel C21-1; b: A family based on C21-1; c: Similar ornaments with two parts.

9

A Festival of Flourishes

"Be fruitful and multiply..." —Genesis 1:28
"Be festive and flourish!" —Guillermo Ildebrando

Here follows a collection of flourish examples including broad pen, pointed pen and pointed brush techniques. The first three are pointed pen examples intended specifically to supplement the text of Chapters 3 and 4. The balance comprises a miscellany of examples of all kinds. The examples are numbered to correspond to the notes at the end of this section. All examples are by the author except where specifically attributed in the notes on pages 108 and 109.

1. BASIC FLOURISH ELEMENTS (POINTED PEN)

2. FLOURISH TAKE-OFF POINTS (POINTED PEN)

3. EXERCISES FOR THE POINTED PEN: (DO THESE AT LEAST TWICE SIZE)

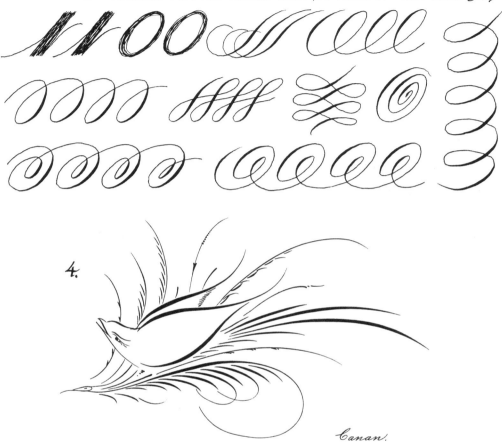

4.

Canan.

C. C. CANAN

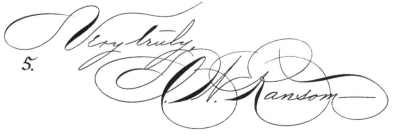

5.

C. W. RANSOM

6.

Roondeaux, sonnets
ou calligrammes,
Acrostiches, strophes
ou epigrammes,
Toutes les rimes
sont dans nos lames,
Pour une Semaine
dans tout Paname.

JEAN LARCHER

7. *Le Victoria*

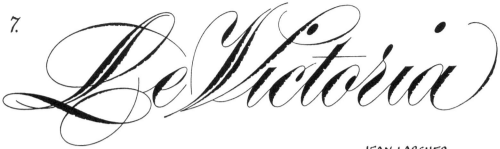

JEAN LARCHER

8. *Alfort, le 6 mai 1993*

Le Directeur,
Professeur R.-L. Parodi

JEAN LARCHER

9. *Mr. Bill Hildebrandt*

25 Beaverbrook Road

West Simsbury, Connecticut

MICHAEL SULL

10.

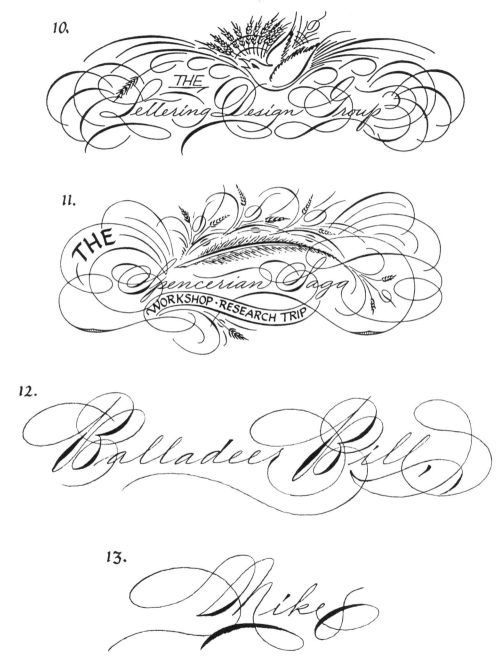

THE *Lettering Design Group*

11.

THE *Spencerian Saga* WORKSHOP · RESEARCH TRIP

12.

Balladeer Bill

13.

Mikes

10 THROUGH 13, MICHAEL SULL

14.

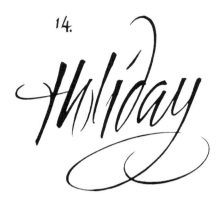

15.

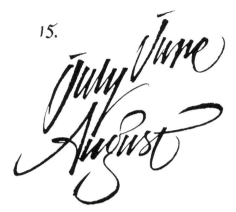

16.

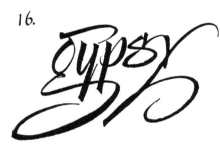

17.

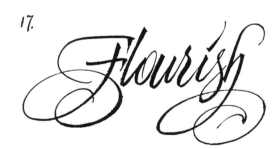

14, 15, 16, 17. FRAN STROM

18.

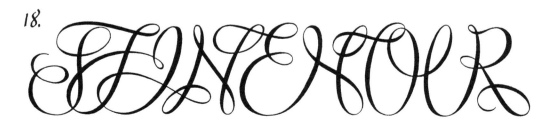

CHRIS STINEHOUR

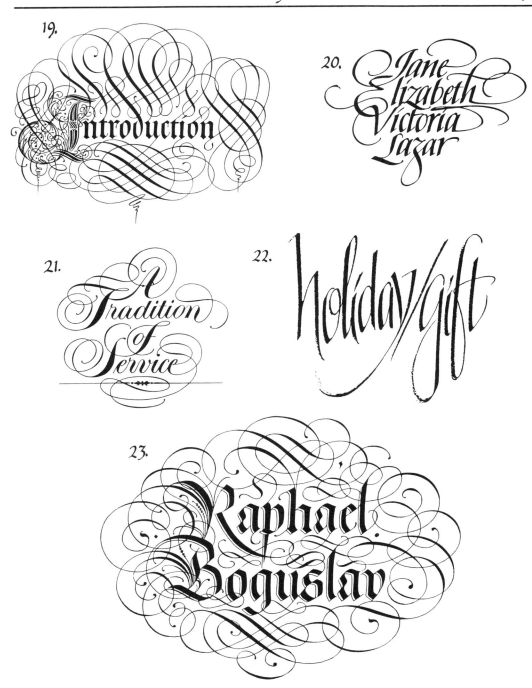

19 THROUGH 23, RAPHAEL BOGUSLAV

24.

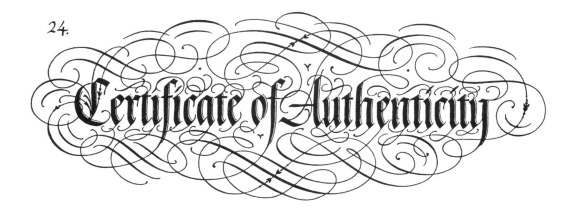

25.

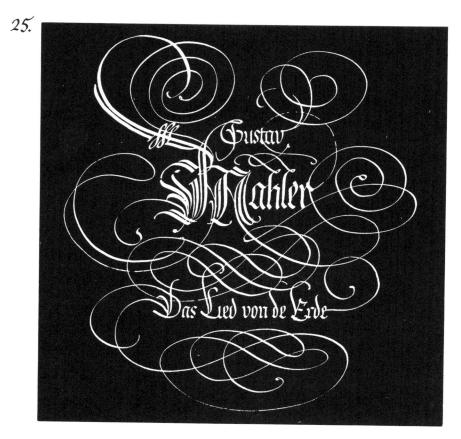

24, 25. RAPHAEL BOGUSLAV

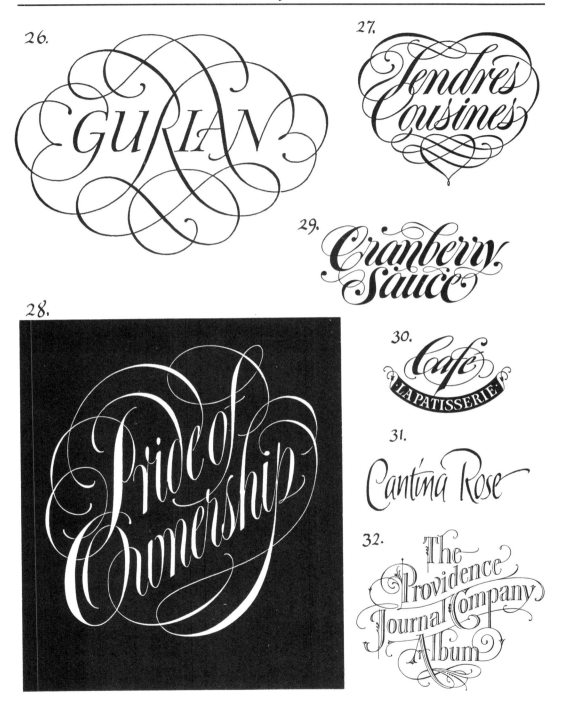

26.

27.

29.

28.

30.

31.

32.

26 THROUGH 32, RAPHAEL BOGUSLAV

33.

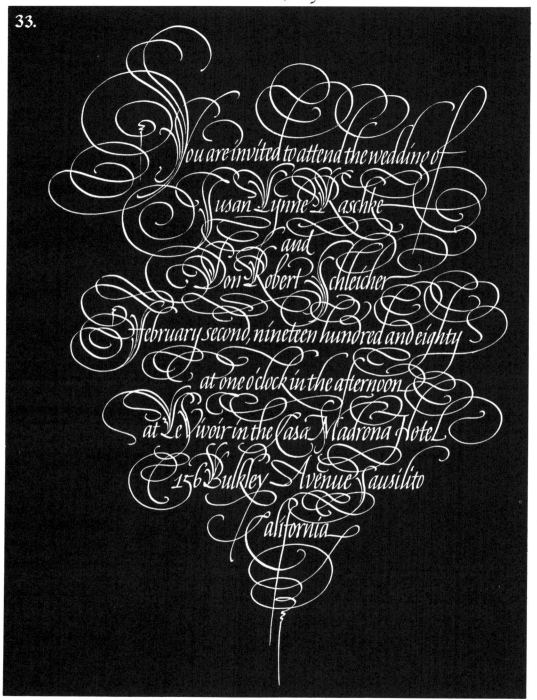

You are invited to attend the wedding of

Susan Lynne Raschke

and

Don Robert Schleicher

February second, nineteen hundred and eighty

at one o'clock in the afternoon

at Le Vivoir in the Casa Madrona Hotel

156 Bulkley Avenue Sausilito

California

RAPHAEL BOGUSLAV

34.

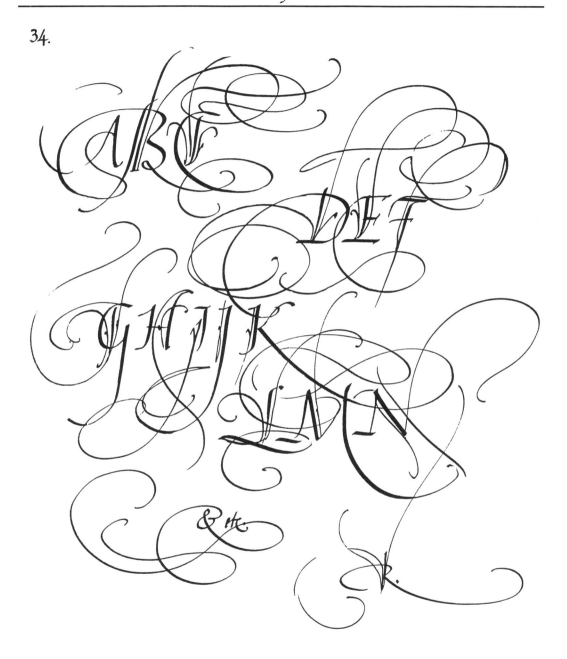

RAPHAEL BOGUSLAV

35.

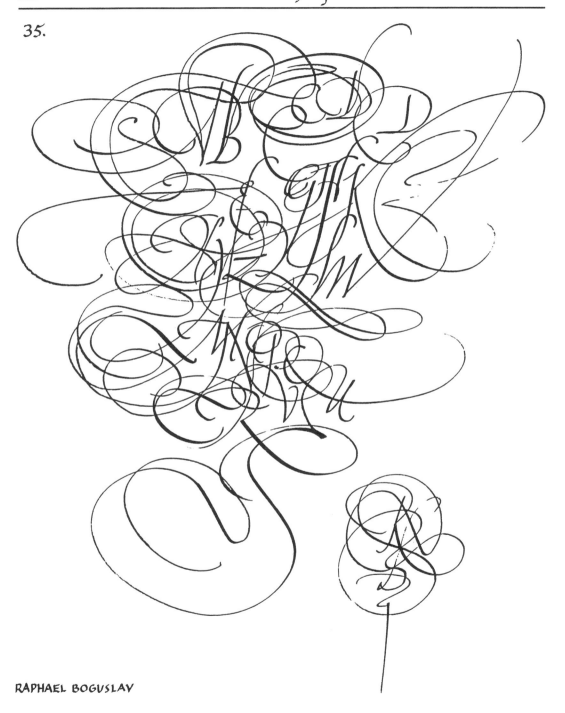

RAPHAEL BOGUSLAV

36.

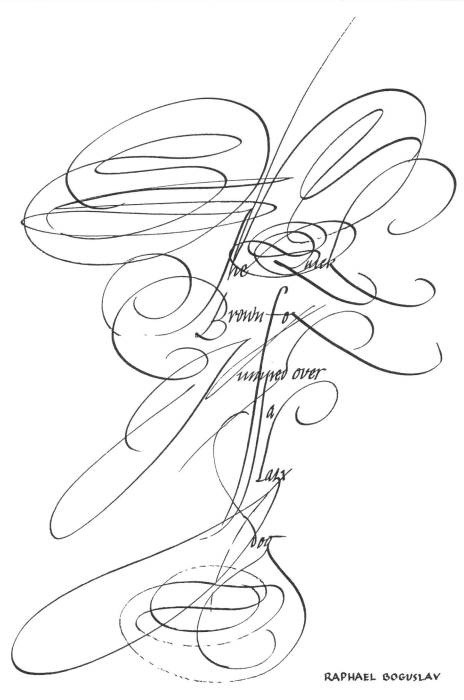

RAPHAEL BOGUSLAV

37.

LOUIS MADARASZ

38.

UNKNOWN

39.

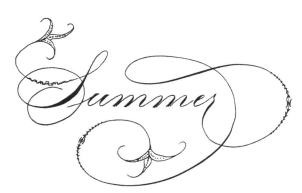

40.

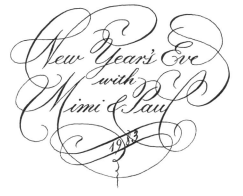

41.

Victorian frills
and here's the reason:
Winter's here,
and it's the season —
To wish both peace
and love to all,
To bake the pies,
to deck the hall,
To greet old friends,
to spread good will;
We'll do our best!
Love, Phyll & Bill.

Season's
Greetings
from
The Hildebrandts
1989

42.

43.

Autumn

44.

Newsletter

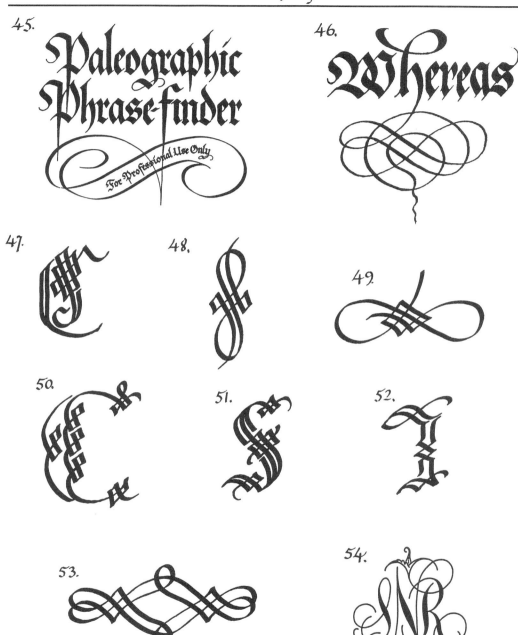

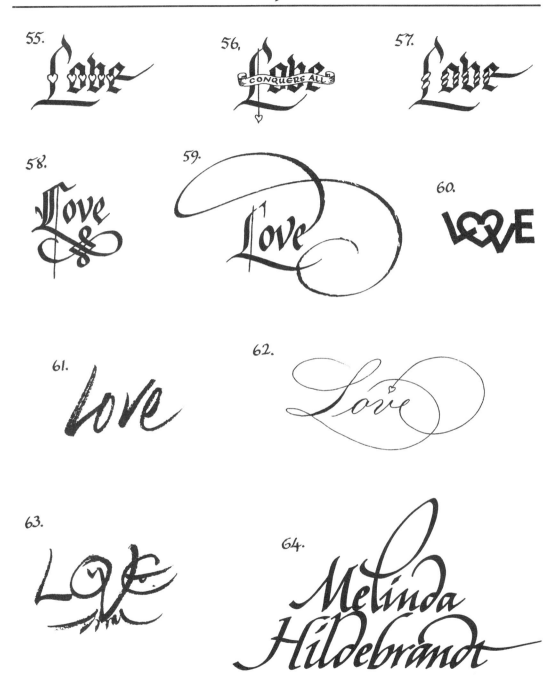

55.

56.

57.

58.

59.

60.

61.

62.

63.

64.

Notes on the Examples

(Where original artwork was available, the reduction percentage is given.)

1. The basic flourish elements with the pointed pen, to supplement Fig. 24, page 20. (65%) These were done with the oblique penholder, which was invented c. 1830, and is used for both Copperplate and Spencerian Script today. Prior to 1830, all pointed pen scripts were done with straight shafted quills and penholders. (Steel pen nibs were not widely available until after 1800.) Traditionally, ornamental flourishing (e.g. example 4) was done with a short straight penholder or quill held as in Figs. 10 and 11, page 12. Some contemporary writers, however, use the oblique holder for ornamental flourishing; Michael Sull, author of "Spencerian Script and Ornamental Penmanship" is planning a book on ornamental flourishing using the oblique penholder.

2. Basic flourish take-off points for Copperplate minuscule. (65%)

3. Exercises for the pointed pen. These should be done twice size to begin with. All other exercises in the main text may be done with the pointed pen in a similar manner. (65%)

4. Ornamental flourish, Clinton C. Canan, c. 1900, author's collection. (50%) Canan was one of about two dozen masters of the golden age of ornamental penmanship (c. 1880-1920).

5. Ornamental penmanship, Spencerian, C. W. Ransom, 1899, author's collection. (65%)

6. Anglaise, (18 c. European Copperplate), Jean Larcher, 1993 (from "L'Anglaise with Jean Larcher," Paris, © 1993, with permission). M. Larcher is a lettering artist and teacher with a studio in Paris, France. He uses the straight penholder for his work instead of the oblique holder (which he refers to jokingly as the "orthopedic holder"). The author has tried the straight penholder for Copperplate and the results are excellent.

7 and 8. Anglaise, Jean Larcher, loc. cit.

9. Michael Sull, Spencerian, 1989, author's collection. (65%) (with permission) Michael Sull, author and lettering artist, is the founder and owner of the Lettering Design Group in Prairie Village, Kansas, and originator of the Spencerian Saga.

10 and 11. Ornamental penmanship, Michael Sull, c. 1988, loc. cit.

12 and 13. Spencerian, Michael Sull, 1991, author's collection, loc. cit. (100%)

14. Pointed brush calligraphy, Fran Strom Sloan (from "The Pointed Brush Calligraphy Manual" by Fran Strom, Aha Calligraphy, 1989, with permission). Fran Strom is a calligrapher and teacher with a studio in Portland, Oregon.

15, 16, 17. Pointed brush, Fran Strom Sloan, loc. cit.

18. Pointed brush, Chris Stinehour, 1993, with permission. Chris Stinehour is a letter carver and calligrapher with a studio in Berkeley, California.

19. Contemporary Baroque style, Raphael Boguslav, with permission. Raphael Boguslav is a lettering artist and logo designer with a studio in Newport, Rhode Island.

20 through 36 inclusive. Examples of the wide variety of flourish work created by Raphael Boguslav, ranging from artwork for reproduction and logo design to just plain fun, loc. cit.

37. Calling card written by Louis Madarasz, c. 1904, author's collection (100%.) During the Victorian era visiting cards (calling cards) were considered most stylish if they were hand written. Professional penmen would write these for 25 to 50 cents a dozen. Madarasz was judged to be the most highly skilled practitioner in the ornamental penmanship genre.

38. Cadel initials B, I and H from late medieval service books (antiphonaries or graduals), author's collection, scribe unknown. (30%) These letters were originally five inches high on a page size of 22 by 30 inches.

39. Copperplate, Bill H. (72%) Some typical Victorian frills added to the flourishes.

40. Copperplate, Bill H. (50%) Cocktail napkin design.

41. Spencerian and Copperplate, Bill H. (64%) Greeting card design.

42. Ornamental penwork, Bill H. (50%)

43. Broad edge pen on rough paper, Bill H. (64%)

44. Masthead design, Bill H. (64%)

45. Fraktur title with pointed pen flourish, Bill H. (40%)

46. Fraktur with appended flourish, Bill H. (75%)

47 through 53. Cadel examples, Bill H. (75%)

54. Logo design, Bill H. (25%)

55 through 63, Bill H. Variations on the word Love. (75%) 55, 56 & 57 illustrate interrupted stroke. 61 & 63 are pointed brush calligraphy. (60 & 63 are visual puns.)

64. Logo design, Bill H. (36%)

Suppliers

General Supplies & Books

John Neal, Bookseller,
 P.O. Box 9986,
 Greensboro, NC 27429
 800-369-9598
 www.johnnealbooks.com

Paper & Ink Arts,
 3 North Second Street,
 Woodsboro, MD. 21798
 800-736-7772
 www.paperinkarts.com

Bibliography

Materials and Tools, and Basic Calligraphic Technique

Lettering & Calligraphy, Lawther & Lawther, North Light Books, 1987
The Encyclopedia of Calligraphy Techniques, D. H. Wilson, Running Press, 1990
The Complete Guide to Calligraphy, Judy Martin, Chartwell, 1984
The Complete Calligrapher, Frederick Wong, Watson-Guptil, 1980
The Calligrapher's Handbook, Heather Child, Ed., A&C Black, 1985
Pointed Brush Writing, Fran Strom, Aha Calligraphy, Portland,Or., 1989
Pinselschrift (Brush Writing, in German), W. Tafelmaier, Callway Verlag, Munich, 1986

Flourishes

Pictorial

Ornamental Flourishing with the Oblique Penholder, Michael Sull, (to be published)
Ornate Pictorial Calligraphy, E. A. Lupfer, Dover, 1982
Pictorial Calligraphy & Scrollwork, van Horicke, Dover, 1985
Pictorial Calligraphy & Ornamentation, Gillon, Dover, 1972

General

Lettering as Drawing, Nicolete Gray, Taplinger, 1982
Ornamental Penmanship, Tomkins & Milns, Dover, 1983
The Universal Penman, Bickham, Dover, 1954
Masterpieces of Calligraphy, Jessen, Dover, 1981
Three Classics of Italian Calligraphy, Dover, 1953
Penmanship of the xvi, xvii & xviii Centuries, Day, Batsford, 1978
Advanced Calligraphy Techniques, Hoare, Chartwell Books, 1989
A Book of Formal Scripts, Woodcock, Godine, 1993
Masters of the Italic Letter, K. A. Atkins, Godine, 1988
Calligraphy and Paleography, A. S. Osley, Ed., Faber, 1965

Spencerian

Spencerian Script, Michael Sull, LDG Publishing, 1989
Ames' Compendium, Daniel Ames, ST Publications, 1978

Copperplate

> Roundhand and Flourishes, Blackwell, Blackwell, n.d.
> Script Lettering for Artists, Thompson, Dover, 1965
> 850 Calligraphic Ornaments for Designers, Takahashi, Dover, 1983
> The Art of Hand Lettering, Wotzkow, Dover, 1967

Baroque

> Handwriting Manual, Fugger, Oxford Univ. Press, 1960
> Schön schreiben, ein Kunst, Doede, Prestel Verlag, Munich, 1957

Cadels

> Medieval Calligraphy, Marc Drogin, Abner Schram, 1980
> Ornamental Initials, Stephen Harvard, Plantin Museum, N.Y., 1974
> Initials from French Incunabula, Lehmann-Haupt, Aldus, 1948
> Calligraphy, Johann Schwander, Dover, 1958
> Alphabets and Ornaments, Ernst Lehner, Dover, 1952
> Thesauro de Scrittori, Ugo da Carpe, Nattali & Maurice, London, 1968
> Augustino da Siena, Alfred Fairbank, David Godine, Boston, 1975

History of Calligraphy

> The History & Technique of Lettering, Nesbitt, Dover, 1957
> The Pen's Excellencie, Whalley, Taplinger, 1980
> The Art of Lettering, Albert Kapr, K. G. Saur, München, 1983
> The Art of Written Forms, Donald Anderson, Holt, Rinehart & Winston, 1969
> The Story of Writing, Jackson, Taplinger, 1981

Celtic Knotwork

> Celtic Art, George Bain, Dover, 1973
> Handbook of Celtic Ornament, John Merne, Mercier Press, 1974
> Celtic Knotwork, Iain Bain, Constable, London, 1986
> Celtic Knots, Mark Van Stone, Alphabet Studio, Colorado, 1992

Index

This book was designed by the author, who also set the type and did those illustrations not otherwise attributed. The two typefaces used throughout the book were designed by the author and are based on his upright Italic Script and his Square Roman Capitals. The main text is set in 19 point Willscript and the subheads in 14 point Balladeer.
The paper is a Finch acid-free sheet and
the whole was printed and made
up into a book at
Daamen,
Inc.